# PORTRAIT MINIATURES FROM
# THE MERCHISTON COLLECTION

SUPPORTED BY DUNARD FUND

# PORTRAIT MINIATURES

## FROM THE

# MERCHISTON COLLECTION

STEPHEN LLOYD

NATIONAL GALLERIES OF SCOTLAND

MMV

Published by the Trustees of the
National Galleries of Scotland for the exhibition
*Portrait Miniatures from the Merchiston Collection*
held at the Scottish National Portrait Gallery, Edinburgh
from 23 September to 11 December 2005

ISBN 1 903278 74 0

Photography by Prudence Cuming Associates Ltd
Designed and typeset in Adobe Minion MM by Dalrymple
Printed in Belgium by Snoeck-Ducaju & Zoon

Front jacket: Joseph Daniel
*Unknown Gentleman Holding a Glass of Water*
[25]

Back jacket: Alexander Gallaway
*Mrs Mary Robertson*
[44]

# FOREWORD

OVER THE COURSE OF the last decade the Scottish National Portrait Gallery has made strenuous efforts not only to raise the profile of the portrait miniature within Scotland, but also to bring these exquisite works of art to the attention of both our regular visitors and new audiences. To this end the Portrait Gallery has mounted an annual series of exhibitions supported by scholarly catalogues. The Gallery has also sought to acquire suitable works for the collection whenever they have come on the market. Highlights from the national collection were exhibited at the Gallery in 2004 as *Portrait Miniatures from the National Galleries of Scotland.*

Our dedication to the portrait miniature has encouraged a number of private collectors to place their collections on long-term loan to the Portrait Gallery. In 2001 an exhibition was mounted and a catalogue was produced showcasing *Portrait Miniatures from the Clarke Collection*, featuring outstanding works by British and Continental artists from the late six-teenth to the early nineteenth century. The second exhibition, *Portrait Miniatures from the Dumas Egerton Collection*, was held in 2002, with a selection of over 600 signed works by artists working in Britain at a similar time. This was followed in 2003 by an exhibition of a selection of *Portrait Miniatures from the Daphne Foskett Collection*, featuring works by British artists from the mid-seventeenth to the mid-nineteenth century. Alongside this loan to the Portrait Gallery from the family of the late Daphne Foskett, the post-war doyenne of the study of the portrait miniature, has been the deposit on long-term loan, in 1999, of her working papers and photographs. This archive has already been of great use to scholars and students working in the field over the last few years.

This current exhibition and catalogue of *Portrait Miniatures from the Merchiston Collection* presents to the public for the first time a fine collection of mostly British miniatures dating from the mid-sixteenth to the mid-nineteenth century, assembled

by a Scottish lady during the 1970s and 1980s. This collector has most generously declared her intention to bequeath these miniatures to the Scottish National Portrait Gallery. This exhibition – like the previous ones in the series – has been organised by Dr Stephen Lloyd, senior curator at the Portrait Gallery. He would like to thank the owner for all her assistance and advice; Claudia Hill for her help with the catalogue; Jane Cunningham of the Courtauld Institute of Art, and Prudence Cuming Associates Ltd for their work on the photography of the miniatures. Finally, special thanks must be given to Dunard Fund, who are not only supporting this exhibition and publication, but have also had the foresight to support the five-year programme of exhibitions and catalogues devoted to the miniature at the Scottish National Portrait Gallery.

SIR TIMOTHY CLIFFORD
*Director-General*
*National Galleries of Scotland*

JAMES HOLLOWAY
*Director, Scottish National Portrait Gallery*

# THE MERCHISTON COLLECTION OF PORTRAIT MINIATURES

The portrait miniature, painted in watercolour on vellum or ivory, was a highly specific form of intimate image-making that was practised by artists across Europe; from its origins in early sixteenth-century Renaissance manuscript illumination until its demise with the invention of photography in the mid-nineteenth century. Initially the portrait miniature acted as a portable gift in diplomatic marriage negotiations among the royal courts of northern Europe. However, it was among the social elite of post-Reformation Elizabethan England that the creation and exchange of limnings or miniatures took hold most securely, as epitomised by the dazzling portraiture of Nicholas Hilliard [3, 4]. His limnings of the queen and her court were often set inside jewelled lockets that would be worn on the body as a token of love or loyalty. These courtly and emotional functions, which were integral to the whole process of commissioning, giving and wearing miniatures, continued throughout the history of the format.

During the seventeenth and eighteenth centuries, the Continental tradition of portrait miniature painting was closely allied to court culture. However, in Britain during this period miniaturists were increasingly prospering outside the court, especially among the wealthier sectors of society such as the landed gentry and the merchant classes. During the late eighteenth and early nineteenth century the painting of portrait miniatures became increasingly popular across the major population centres of Britain and Ireland. Miniatures continued to function principally as portable likenesses of loved ones, especially in their absence. They acted not only as objects of affection, such as engagement or marriage portraits, but also as focal points of memory, in particular as memorials to recently deceased members of the family. During the final phase of the miniature, just before the advent of inexpensive photography in the 1840s, artists increased the size of the painted ivory surface in an attempt to compete

with small oil paintings as well as portrait drawings and watercolours on paper [68]. These larger 'cabinet' miniatures from the late Regency and early Victorian period, works that were mainly intended for domestic display within room settings, are particularly well represented within the Merchiston collection.

The collector of the Merchiston miniatures set herself a clearly defined goal during the 1970s and 1980s: to build a discrete assemblage of around seventy-five portrait miniatures comprising high-quality examples – if possible signed – by many of the most important artists working in Britain and Ireland from the mid-sixteenth to the mid-nineteenth centuries. This was the collection remit encouraged by Daphne Foskett (1911–1998), the post-war doyenne in the field, who published extensively on portrait miniatures between the early 1960s and late 1980s. Foskett's publications included monographs on Samuel Cooper and John Smart, a major survey exhibition at the Edinburgh International Festival in 1965, and a popular dictionary of British portrait miniaturists, which was first published in 1972. Over that same period Foskett advised and inspired a number of the most important private collectors in Europe and North America.

The strength of the Merchiston collection is to be found not only in the quality of works (painted by some of the greatest artists in the field, such as Hilliard, Cooper, Cosway and Smart), but also in the depth of representation of slightly less well-known artists such Richter, Lens, A.E. Chalon and Ross. There are miniatures from a wide geographical spread, including examples not only by English painters based in the metropolis of London, but also by Irish and Scottish painters. From Ireland there are portraits by the Hones (father and son), Sullivan, Place, Andrews, the Robertson brothers, Roch and Sir F.W. Burton (later a director of the National Gallery in London), while from Scotland there are miniatures by Scouler, Bogle, Skirving, Shirreff, Gallaway, Robertson, Cruickshank and Thorburn. Portraits were painted in major regional centres such as Bath (Daniel), Liverpool (Biffin), Edinburgh (Gallaway) and Dublin (Horace Hone). In addition, there are miniatures by artists from the Continent who came to work in Britain, such as Richter, Arlaud, Meyer, A.E. Chalon and Rochard. Other miniatures were painted by artists who worked abroad, such as Diana Hill [32] and Samuel Andrews [38] in India. The Merchiston collection is especially strong on

miniatures painted between around 1750, during the revival of the portrait format on ivory, and 1850, when the miniature business collapsed in the face of the relentless rise of a new form of image making – photography.

The collector, who has a deep interest in key personalities from British history, has been keen to acquire miniatures of known sitters wherever possible, some of whom were notable protagonists in their lifetime. Pre-eminent among these is the pair of tiny lockets by Nicholas Hilliard depicting *Queen Elizabeth* and her admirer *Robert Dudley, Earl of Leicester* [3, 4]. Of outstanding interest from the seventeenth century is Samuel Cooper's painting on vellum of the Irish magnate *James, 12th Earl and later 1st Duke of Ormonde* [5], and that by Richard Gibson of *Anne Hyde, Duchess of York* [6], the first wife of James VII & II. From the later eighteenth century there are miniatures by Samuel Cotes of the noted actress *Mrs Yates* [22] and by Diana Hill of *Sir Charles Cockerell Bt* [32], who was a key figure in the East India Company. From the first half of the nineteenth century the collection features a number of miniatures of aristocratic women such as *Sarah Sophia, Countess of Jersey* [54] by A.E. Chalon, and *Baroness Howard de Walden and*

*her Three Children* [68] by Sir William Charles Ross.

The works were purchased on the London art market, principally through the specialist dealers known as Limner, between 1971 and 1990. As is often the case with serious collectors, these acquisitions were gradually refined with many miniatures being sold as examples of a higher quality became available. At its greatest extent the Merchiston collection numbered 218 works – nearly three times its final size. It is a striking instance of how a collection of fine portrait miniatures can be formed by a private individual on a limited budget and within a circumscribed period of time.

The formation of the Merchiston collection took place over two periods, the first from 1971 to 1979, and the second between 1986 and 1990. During the 1970s portrait miniatures were relatively inexpensive to buy, and the forty-five miniatures purchased over that first period of collection cost on average £350, with by far the most expensive acquisition being the pair of Hilliard lockets in 1976. During the early 1980s the collector entered a phase of consolidation when the collection was refined and over 130 miniatures were sold in an effort to improve the overall quality. By the time of the second phase

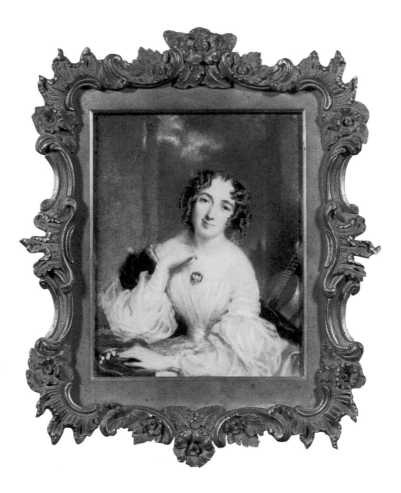

Sir Frederic William Burton, *Unknown Lady*, 1836 [69]

of collecting during the latter half of the 1980s, when thirty miniatures were added costing on average £1,150, prices had more than tripled. Over this second phase of collection building the three most expensive works acquired were by the eighteenth-century miniaturists, George Engleheart [37], John Smart [23] and Nathaniel Hone [16].

The formation of the Merchiston collection provides a fascinating insight into how a collection is assembled. As with any collection this depends on financial resources and the availability of particular works on the art market. In 1971 the first three miniatures were acquired – nineteenth-century works by J.C. Engleheart [48], Robert Thorburn [67] and Sir F.W. Burton [69]. The following year saw the purchase of the Cooper [6], one of the Richters [10], the pair by Lens [12, 13], the Daniel [25], and nineteenth-century works by Rochard [53] and Tidey [73], as well as two portraits each by A.E. Chalon [49, 54] and Ross [71, 74]. On average about five miniatures a year were added to the collection. Other notable acquisitions during the 1970s included the second Richter [9] in 1973, the Shelley group portrait [28] in 1974, the Gibson [6] in 1975, the pair of Hilliard lockets in 1976, and the Charles Beale [7] in 1977.

During the second half of the 1980s the collector began her second period of acquisitions. The Cosway [27], the Barry [31] and the Edridge [43] were returned to the collection in 1986, having originally been purchased during the early 1970s and then sold in 1984. A major group of late eighteenth-century miniatures were bought in 1987, a year in which twelve works joined the collection, including choice pieces by Sullivan, [18] Crosse [21], Smart [23], Shirreff [29], Hazlehurst [36], Engleheart [37], and Wood [41]. The following year a group of miniatures from the same period was acquired, including works by Spencer [14], Scouler [17], Humphry [19], Horace Hone [30], Place [34] and Andrews [38]. The collection was completed in 1990 with the purchase of two miniatures, the Nathaniel Hone [16] and the Meyer [20].

Despite its strong showing of miniaturists working in Britain and Ireland from the mid-eighteenth to the mid-nineteenth century, the Merchiston collection does not claim to be completely representative. While works by Continental and American artists were mostly excluded on purpose, miniatures by artists working on vellum from the 1520s to the early eighteenth century are relatively rare and expensive to acquire. As a result of this restriction, examples by Hilliard, Cooper,

Gibson and Cross are included while limnings by the Olivers (father and son), Hoskins, Flatman and Dixon are absent. Miniature portraits painted in oil and in emamel, as well as plumbagos (drawings in lead point on vellum) are also deliberately absent. Also some miniaturists from the eighteenth and nineteenth century are not represented including, for example, Penelope Carwardine (*c.*1730–1801), John Downman (1750–1824), François Ferrière (1752–1845) and Christina Robertson (1796–1854).

However, it is invidious to point out such omissions in such a well rounded group of work as is presented in the Merchiston collection. Rather than being seen as comprehensive, it should be considered as representative of one collector's passionate eye for the remarkable, continuous traditions of portrait miniature painting on vellum and ivory in the British Isles, from the Elizabethan era to the early years of Queen Victoria's reign.

# COLOUR PLATES

PLATE 1A

## NICHOLAS HILLIARD

### *Queen Elizabeth (1533–1603) c.1575*

Bodycolour on vellum stuck to plain card, set in
gilt-metal locket; 1.8cm (¾in) high

PLATE 1B

## NICHOLAS HILLIARD

### *Robert Dudley, Earl of Leicester (1532–1588) c.1575*

Bodycolour on vellum stuck to plain card, set in
gilt-metal locket; 1.8cm (¾in) high
COLLECTIONS: Mr R.H. Spurway, Fredericton,
New Brunswick; Christie's, London, 28 October
1970, lots 123–4
EXHIBITED: London 1983, p.118, nos.185–6, ills.

In this pair of tiny, exquisite miniatures painted around 1575 Queen Elizabeth wears a jewelled headdress, which has a veil falling from it. She wears a richly jewelled necklace and lace-edged ruff up to her chin, and these are offset against her severe black dress. This portrait, together with the companion piece of the queen's favourite, the Earl of Leicester, shows every sign of having been painted from life, and suggests that they once formed part of a jewel of great personal significance. The gilt-metal lockets are of a later date. The figure of Elizabeth is one of the most familiar in sixteenth-century European history and it was the master limner Nicholas Hilliard (1547–1618) who did much to create the image of the Virgin Queen, ageless and clad in a variety of rich and fantastic costumes. This miniature is closely related to the contemporary 'Darnley' portrait of Elizabeth painted in oils (National Portrait Gallery, London).

Robert Dudley, who was the fifth son of John, Duke of Northumberland, won the heart of the queen early in her reign, and she remained devoted to him until his death from fever during the Armada campaign. He became Master of the Horse, a Knight of the Garter and, in 1564, Earl of Leicester. The mysterious death of his first wife, Amy Robsart, formed the basis of Sir Walter Scott's romantic novel, *Kenilworth*. In 1578 Leicester married Lettice Knollys, the widowed Countess of Essex, who was then banished from court by Elizabeth. A similar, larger and circular miniature of Leicester by Hilliard exists (National Portrait Gallery, London).

CATALOGUE 3 & 4

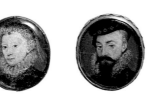

PLATE 2

## SAMUEL COOPER

### James, 12th Earl and later 1st Duke of Ormonde (1610–1688) 1647

Bodycolour on vellum stuck to plain card, set in silver scroll-top frame; 5.1cm (2in) high; signed and dated on recto: *s.c. / 1647*
COLLECTIONS: S.V. Hickson; Sotheby's, London, 22 April 1968, lot 58

James Butler was the head of the great Irish-Norman family, but he was brought up in England as royal ward and educated as a Protestant. In 1629 he married his cousin, Elizabeth Preston, daughter of the Earl of Desmond and heiress to half the Butler estate. They had ten children and remained a deeply devoted couple, based at their principal seat of Kilkenny Castle. Ormonde was an ardent royalist and Charles I created him a marquess in the Irish peerage during 1642. Two years later he became Lord-Lieutenant of Ireland and did much to rally support for the king. However, with the collapse of the royalist cause he had to surrender Dublin to Parliament.

This portrait was painted in London when Ormonde visited the king, who was then imprisoned at Hampton Court, before travelling on to join the exiled royalists in Paris. Ormonde is depicted against a blue background, wearing black armour and a plain white collar. This miniature is a fine example from the Civil War period by the master limner Samuel Cooper (1608?–1672), showing his remarkable ability to portray the sitter's character. A year later Ormonde sat in Paris for a similarly posed portrait in oils by Justus van Egmont (Verney Collection, Claydon House, The National Trust). Cooper, having been trained as a miniaturist by his uncle, John Hoskins, had established himself as an independent artist in London by 1642. The extraordinary realism of his portraiture ensured that he had many clients during the Civil War, the Interegnum, and the early years of Charles II's reign.

The Restoration in 1660 brought Ormonde a dukedom in both the Irish and English peerages (1661 and 1682). Two years later Charles II appointed him Lord-Lieutenant of Ireland and he ruled, with one break from 1669–77, until he retired in 1685.

CATALOGUE 5

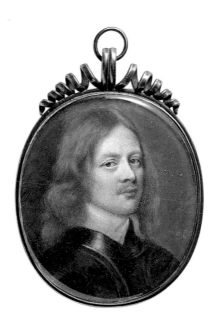

PLATE 3

RICHARD GIBSON

*Anne Hyde, Duchess of York (1637–1671)*
*c.1662*

Bodycolour on vellum stuck to plain card, set in
gilt-metal frame; 6.3cm (2½in) high
COLLECTIONS: Sotheby's, London, 15 March
1971, lot 65
REFERENCES: London & New Haven 2001–2,
pp.72–6

Anne Hyde was the eldest daughter of
Edward, 1st Earl of Clarendon. In 1654
she was maid of honour to Princess Mary
of Orange and attracted the attention of
Mary's brother, James, Duke of York,
while at Breda in the Netherlands during
1659. They became secretly engaged but,
before the marriage could take place,
Charles II was recalled to the throne in
London. Anne, by this time pregnant,
returned to England and was secretly
married to James. Of her eight children
only two, the future queens Mary and
Anne, survived. Although brought up as
a Protestant, Anne had become a Catho-
lic some time before her death from
cancer. Her widowed husband married
Mary of Modena and was later crowned
James VII & II.

This miniature was painted by Richard
Gibson (1615–1690) soon after the Restora-
tion of Hyde's brother-in-law Charles II.
It can be related to two other contempo-
rary portraits of her: the three-quarter
length by Sir Peter Lely (Scottish National
Portrait Gallery, Edinburgh) from about
1660 and the miniature by Samuel Cooper
(Private Collection), painted about a year
later.

Gibson was a dwarf at the court of
Charles I. He married another dwarf, Anne
Shepherd, but all their surviving children,
including the miniaturist Susannah-
Penelope (Rosse), were of normal size. He
was a friend of Sir Peter Lely and took up
miniature painting, producing some fine
copies after Lely's portraits. Gibson was
later attached to the household of Anne,
Duchess of York, and was drawing master
to her daughters Mary and Anne. In 1677
he accompanied Princess Mary to Holland
on her marriage to William of Orange. He
returned to London in 1688, and died two
years later.

CATALOGUE 6

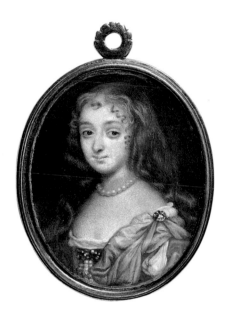

PLATE 4

# CHARLES BEALE 'THE YOUNGER'

## *Charles Taylor* 1689

Bodycolour on vellum, set in contemporary gold scroll-top frame; 3.8cm (1½in) high; verso of frame engraved with sitter's coat-of-arms and inscription: *Carolus Taylor gen. Natus 8 die Decemberis 1656. Delineatus 22 die Februarii 1689.* COLLECTIONS: Christie's, London, 16 November 1976, lot 67
REFERENCES: Murdoch 1997, pp.251–8

Charles Beale 'the younger' (1660–1714) was the second son of Charles Beale 'the elder' and his wife Mary, who was a well-known professional portrait painter. The younger Charles showed aptitude as an artist at an early age and became a studio assistant to his mother. However, problems with his eyesight curtailed his career as a miniaturist after less than five years activity. Following his mother's death he remained in London to the end of his days, and is not known to have married or had children.

The miniatures that have been attributed to him – as with those given to his mother – are problematic in that there is little consistency in their appearance or style. Miniatures that can confidently be attributed to the younger Beale are marked by a soft stippling in the faces of the sitters. A group of his vigorous figure drawings in red chalk survive (The British Museum, London), which can be dated to around 1680. Nothing is known of Charles Taylor, except that he was aged thirty-two when he sat for this miniature.

CATALOGUE 7

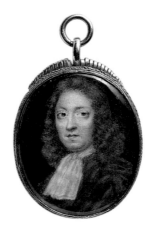

PLATE 5

CHRISTIAN RICHTER

*Unknown Lady Holding a Dove*
*c.*1705

Bodycolour on vellum stuck on plain card, set in
original closing shagreen and metal case;
7.6 × 5.1cm (3 × 2in)
COLLECTIONS: Purchased in 1973
REFERENCES: Murdoch *et al.* 1981, pp.165–7

Born in Stockholm, Christian Richter
(1678–1732) was apprenticed to a gold-
smith and studied metal engraving. After
visits to Berlin and Dresden, he moved to
London in 1702, where he became a
leading miniaturist working on vellum
and, it is said, in enamels, although not
one of the latter has survived. Because of
a facial disfigurement ('venereal distem-
per' according to the early art historian
George Vertue), much of his career was
spent copying in miniature the oil
paintings of Lely, Kneller and his fellow
Swede, Michael Dahl. Richter's mini-
atures – with their distinctive stippling –
are some of the finest such works to have
been painted in London during the first
three decades of the eighteenth century.

CATALOGUE 9

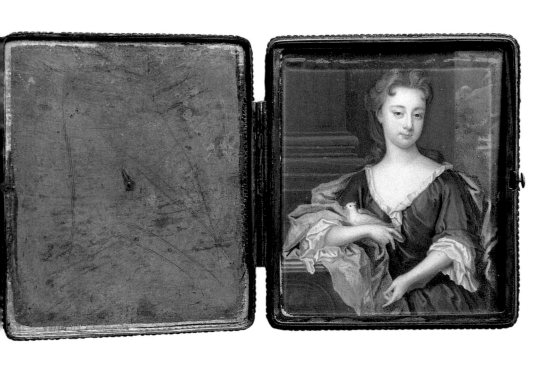

PLATE 6

BENJAMIN ARLAUD

*Unknown Gentleman c.1715*

Bodycolour on vellum, set in silver-gilt frame;
6.4cm (2½in) high
COLLECTIONS: H. Barnes; Sotheby's, London, 29
April 1974, lot 45
REFERENCES: Murdoch *et al.* 1981, pp.166–7

Benjamin Arlaud (*c.*1670–*c.*1719) was
born in Geneva, into a family of clock
makers, and was the younger brother of
the artist Jacques-Antoine Arlaud. Little
is known of his life and career except that
he was active in London between about
1704 and 1717, when he painted his last
known signed and dated miniature. His
earliest signed and dated portrait to have
survived is of William III. Painted in
1701, it is not known whether this was
copied or painted from life. It is very
likely that Arlaud travelled back and
forth between London and the Conti-
nent. While in England he certainly
received commissions from the Duke of
Portland and the Earl of Oxford, and he
also portrayed the Duke of Marlborough
on a number of occasions after the Battle
of Blenheim in 1704. Arlaud modelled
the faces of his sitters with an elaborate
series of hatched brushstrokes, creating
a tightly delineated effect, which was
particularly successful in his direct
portrayals of male sitters.

CATALOGUE 11

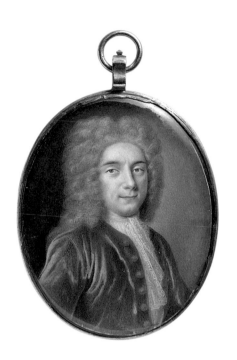

PLATE 7

BERNARD LENS

## William Whitmore (1682–1725) 1718

Watercolour on ivory, set in original turned ivory frame; 8.8cm (3½in) high; signed and dated on recto: B.L. *1718*; inscribed and signed on verso: *William Whitmore Esq. of Apley in Shropshire. Bernard Lens fecit 1718.*
COLLECTIONS: Whitmore family collection; Christie's, London, 2 November 1971, lot 115
EXHIBITED: London 1988, no.112
REFERENCES: Coombs 1998, pp.80–3

William Whitmore owned the estates of Apley in Shropshire and Lower Slaughter in Gloucestershire, the manor of the latter village having been granted to George Whitmore by James VI & I in 1608. William was Member of Parliament for Bridgnorth from 1705 to 1710 and again from 1715 to 1725. He married Elizabeth Pope and had twelve children. His eldest son, Thomas, was created a baronet.

Between 1716 and 1731 Bernard Lens painted fifteen miniatures of the Whitmore family, all of which were dispersed at auction in 1971. A miniature of one of William Whitmore's sons, Richard, shows him as a child holding a toy hobby horse, and is dated 1718 (Victoria & Albert Museum, London). This series includes some of the finest works to have been painted by Lens, some of which still have their original turned ivory frames. A pair of three-quarter-length oil portraits of Mr and Mrs William Whitmore, painted by Sir Godfrey Kneller around the same time as the miniatures, was sold at auction in London (Phillips, 13 December 1982, lot 116).

CATALOGUE 12

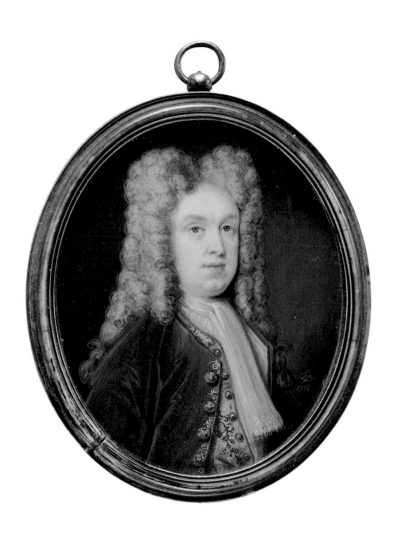

PLATE 8

BERNARD LENS

## Elizabeth Pope, Mrs William Whitmore (1681–1735) and her son Charles (1716–1770) 1716

Watercolour on ivory, set in original turned ivory frame; 8.8cm (3½in) high; signed on recto: B.L.; inscribed and signed on verso: *Elizabeth daughter of Roger Pope and wife of Willm. Whitmore of Apley Esq. with Charles their son. Ann. Dom. 1716 aetat 35 by B. Lens.*
COLLECTIONS: Whitmore family collection; Christie's, London, 2 November 1971, lot 115
EXHIBITED: London 1988, no.112
REFERENCES: Coombs 1998, pp.80–3

Bernard Lens (1682–1740), who was the son and grandson of two rather obscure artists of the same name, was the earliest miniaturist to make a career working on ivory, when this new support for painting in watercolour was introduced in the first few decades of the eighteenth century. Also able to paint on vellum, Lens was miniature painter to both George I and II, and his work was much sought after by fashionable society. As well as portraits from life, he made many copies after portraits by other oil painters.

A successful drawing master, he worked in a number of the great English country houses. His sons Andrew Benjamin and Peter Paul were both miniature painters.

This miniature was most probably commissioned to celebrate the birth in 1716 of Charles, Mrs Whitmore's fifth son and seventh child. She eventually bore her husband twelve children. Charles married Mary Kelly from Newcastle-upon-Tyne. He died at Southampton in 1770.

CATALOGUE 13

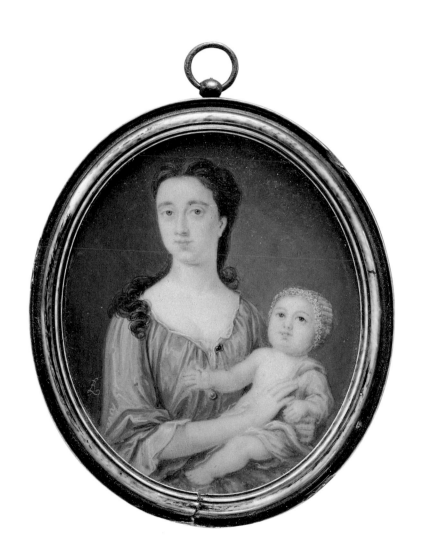

PLATE 9
## SAMUEL COTES
### *Mrs Yates (c.1728–1787) 1776*

Watercolour on ivory, set in black turned wooden frame with ormolu bezel; 8.8cm (3½in) high; signed and dated on recto: *s.c. / 1776*
COLLECTIONS: Robert Bayne-Powell
REFERENCES: Coombs 1998, pp.96–8

Mary Ann Graham began her stage career in Dublin in 1752, and later moved to London. After marrying actor Richard Yates her career developed to such an extent that she became the leading tragic actress of the London stage, until she was superseded by Sarah Siddons. Tall and striking, Mrs Yates had a commanding stage presence and it was said that she could freeze the blood of her audience. Two of her most famous roles were Medea and Margaret of Anjou. She was portrayed by both Reynolds and Romney in oils, while Samuel Cotes also painted another larger three-quarter-length miniature of her in 1769 (Victoria & Albert Museum, London) as Electra from Voltaire's play *Orestes*, which was specially translated for her.

The son of a former mayor of Galway, who later became an apothecary in London, Samuel Cotes (1734–1818) was the younger brother of the better known crayon and oil painter, Francis Cotes. Samuel, who worked on ivory and in enamels, exhibited his portraits in London at the Society of Artists (1760–8) and at the Royal Academy (1769–89).

CATALOGUE 22

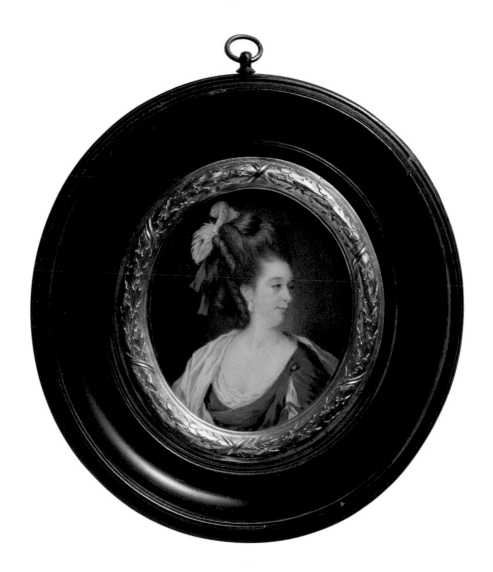

PLATE 10

JOSEPH DANIEL

*Unknown Gentleman Holding a Glass of Water c.1780–5*

Watercolour on ivory, set in ormolu frame;
12.7 × 10.2cm (5 × 4in)
COLLECTIONS: Purchased in 1972
REFERENCES: Foskett 1987, p.254, pl.62
EXHIBITED: Bath 2002, p.95, no.67, ill.

The Jewish artist Joseph Daniel (*c.*1760–1803) was a son of Nochaniah Daniel of Bridgwater in Somerset and is generally thought to be the miniaturist known as 'Daniel of Bath', who worked in that fashionable spa town during the last two decades of the eighteenth century. Daniel is also known to have practised in Bristol and London as a miniaturist, sometimes working in crayons and oils. He exhibited very occasionally in London. His brother, Abraham Daniel, worked as a miniaturist, jeweller and engraver mainly in Plymouth. The miniatures of the two brothers are difficult to distinguish, especially as neither artist signed their work.

The unknown sitter in this miniature points with his left hand to a glass of water that he is holding in his right hand. This is most likely to be a glass of the beneficial chalybeate water of Bath, and this miniature may have been commissioned by the sitter after his health had been restored on a visit to this preeminent health resort.

CATALOGUE 25

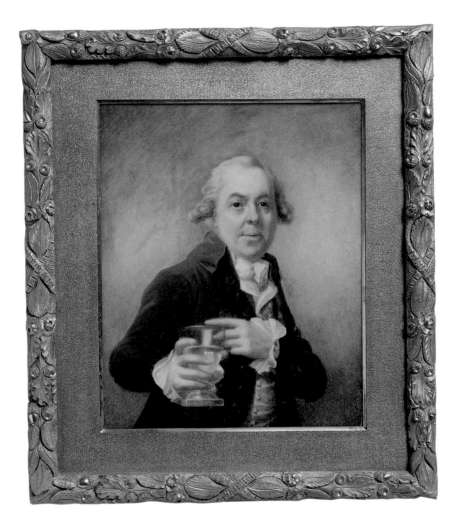

PLATE 11

# JOHN BOGLE

## *Unknown Gentleman* 1782

Watercolour on ivory, set in gold locket frame;
3.8cm (1½in) high; signed on recto: *J.B. / 1782*
COLLECTIONS: Purchased in 1986
EXHIBITED: Edinburgh 1999, p.58 no.33

John Bogle (1738–1804) was one of the
finest and most prolific portrait minia-
turists working in London in a veristic,
or highly realistic, style during the last
three decades of the eighteenth century.
The son of a Scottish excise officer, he
studied at the Foulis Academy in Glas-
gow, before working as a miniaturist in
Edinburgh. After moving to London, he
exhibited his miniatures at the Society of
Artists (1769–70) and at the Royal
Academy of Arts (1772–94). He returned
to Edinburgh in 1799, where he remained
until his death. Bogle usually signed his
work with his initials or in full on the
front of the miniature. The Scottish art
critic, Allan Cunningham, described
Bogle as 'a little lame man, very poor,
very proud and very singular'.

CATALOGUE 26

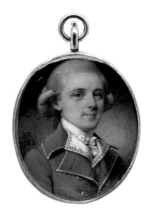

PLATE 12

SAMUEL SHELLEY

## A Family Group: an Unknown Gentleman and Two Ladies c.1785

Watercolour on ivory, set in gilt-wood frame; 10.2 × 13.9cm (4 × 5½in); signed on verso: *Sam. Shelley, Henrietta Street, Covt. Garden* COLLECTIONS: Purchased in 1974

Samuel Shelley (1756–1808) was a native of London, where he lived and worked all his life. As well as painting portrait miniatures, he also executed watercolour drawings, book illustrations and the occasional oil painting. Largely self-taught, Shelley was awarded a premium by the Society of Arts in 1770, and exhibited his work there in 1773 and 1775. He entered the Royal Academy schools in 1774, and showed his miniatures at the Academy from 1774 to 1804. Shelley was known for his skill in using larger pieces of ivory to create portrait groups, which was relatively unusual at this date. Although this work represents a family group, the relationship between the sitters is not clear.

CATALOGUE 28

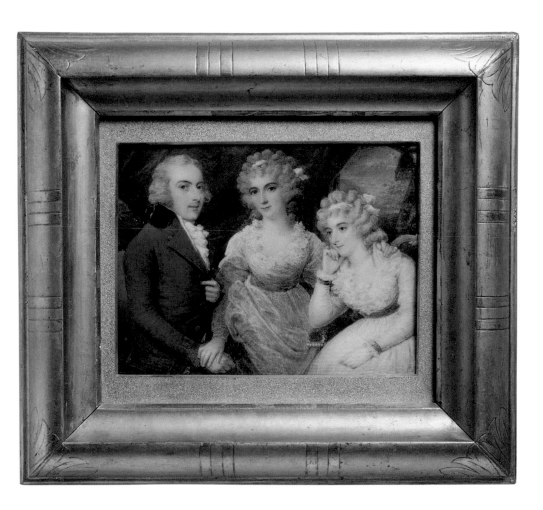

PLATE 13
# CHARLES SHIRREFF
## *Unknown Officer c.1785*

Watercolour on ivory, with gilt-metal frame with blue glass and hair set on verso; 6.4cm (2½in) high
COLLECTIONS: Purchased in 1987
EXHIBITED: Edinburgh 1999, p.58, no.36

Charles Shirreff (*c.*1750 – d. after 1823) was born in Scotland, possibly in Edinburgh, and was deaf and dumb from the age of four. He moved to London in 1768 and entered the Royal Academy schools the following year, winning a silver medal there three years later. He exhibited his work at the Free Society of Artists (1770–3) and at the Royal Academy (1771–1823). Shirreff intended to travel to India in 1778 but the project was abandoned for reasons as yet unknown. He is known to have practised in Bath (1791–5) and is also thought to have worked in Brighton, Deptford and Cambridge. He was given permission to work in India in 1795 and settled first in Madras and then in Calcutta, before returning to London in 1809. In later life Shirreff lived in Bath and London, although his date of death is not yet known. His miniatures tend to be plain and unflattering, but are neatly executed with characteristic cross-hatching used in the modelling and the background.

CATALOGUE 29

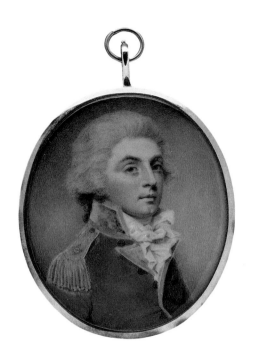

PLATE 14

HORACE HONE

## Ellen O'Brien, Mrs Edmund O'Callaghan 1785

Watercolour on ivory, set in pierced gilt-metal frame; 7.6cm (3in) high; signed and dated on recto: H.H. / 1785
COLLECTIONS: Mrs. Beatrice Grosvenor; Sotheby's, London, 18 July 1988, lot 39

Horace Hone (1754/6–1825) was the second son of Nathaniel Hone, the Irish oil painter and miniaturist, who taught him to paint. Horace entered the Royal Academy schools in 1770, and later exhibited his work at the Academy from 1772 to 1822. He was elected an associate of the Royal Academy in 1779. Hone moved to Ireland in 1782 and established a very successful portrait miniature practice in Dublin, painting mainly on ivory but occasionally in enamels. He became a miniature painter to the Prince of Wales in 1795. After the Act of Union joined Ireland with Britain in 1800 Hone's business in Dublin declined, and four years later he returned to London.

Hone's miniatures vary in quality, but can be elegantly posed. They are usually painted with a stipple technique that is used to model and shade the face. The sitter in this particularly fine miniature, Ellen O'Brien, was the wife of Edmund O'Callaghan; their daughter, Catherine, married Thomas, 3rd Earl of Kenmare.

CATALOGUE 30

PLATE 15

## MRS DIANA HILL (NÉE DIETZ)

### *Sir Charles Cockerell, Bt (1755–1837)*
### 1786

Watercolour on ivory, set in black wooden rectangular frame; 8.8cm (3½in) high; signed and dated on recto: *Hill / 1786*
COLLECTIONS: Christie's, London, 3 October 1972, lot 143
REFERENCES: Foskett 1987, p.328–9, pl.91A

Charles Cockerell was the third son of John Cockerell of Bishops Hull in Somerset. In 1776, when he arrived in Bengal as a writer in the East India Company, he embarked upon a successful career during which he amassed a considerable fortune. By 1788 he was senior merchant and paymaster general. In 1800 Cockerell returned to England and two years later he was elected a Member of Parliament. In 1808 he married Harriet Rushout, the second of the three beautiful daughters of Lord Northwick, and the following year he was created a baronet. Sir Charles's home at Sezincote in Gloucestershire was built for him by his brother the architect Samuel Pepys Cockerell.

Miss Diana Dietz (fl.1775–1844) showed her work at the Society of Artists in London during 1775, and in the same year won an award at the Society of Arts. She also exhibited her miniatures at the Royal Academy from 1777 to 1780. She married a Mr Hill and was widowed sometime before 1785, when she set out for India. There Mrs Hill enjoyed considerable success until 1788 when she appears to have abandoned her career after marrying Lieutenant Thomas Harriott of the 1st Native Infantry, by whom she had two children. After his retirement in 1806 the family returned to England.

CATALOGUE 32

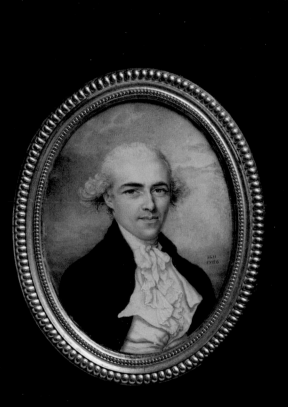

PLATE 16

ALEXANDER GALLAWAY

## Mrs Mary Robertson 1809

Watercolour on ivory, set in gold frame; 7.6cm (3in) high; signed and dated on verso: *A. Gallaway pinxt 1809. Edin. 6 Ja[me]s Square*
COLLECTIONS: Christie's, London, 7 November 1988, lot 118
REFERENCES: Washington 1983
EXHIBITED: Edinburgh 1999, pp.71–2, no.129

The Scottish miniaturist Alexander Gallaway (fl.1794 – d. after 1815) worked in Glasgow and Edinburgh producing highly realistic and frank portrayals. It is known that in 1794 he shared a studio in Glasgow with the landscape water-colourist Hugh William 'Grecian' Williams. On 31 May 1794 the two artists advertised drawing classes in the *Glasgow Courier*, and on 3 June that year they placed the following notice in the same newspaper: 'Miniature Painting by Mr Gallaway, and Views of Any Particular Place, Taken from Nature, By Mr Williams. Specimens to be seen at the Academy.' Gallaway resided at various addresses in Edinburgh from 1804 to 1815, and he exhibited his work in Edinburgh from 1808 in the annual exhibitions organised by the Society of Artists.

Mary Robertson was the sister-in-law of Matthew Sully, who was the older brother of the American portrait painter Thomas Sully. Her portrait by Gallaway is remarkable for its unflinching attention to detail and the close observation of character.

CATALOGUE 44

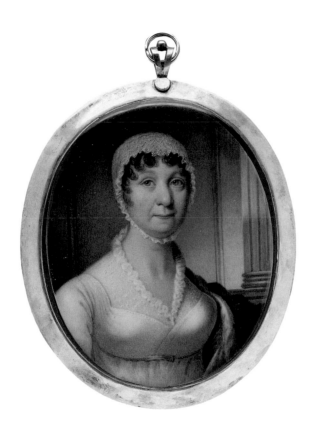

PLATE 17

## SIR WILLIAM CHARLES ROSS

### *Isabella, Dowager Viscountess Hawarden* 1824

Watercolour on ivory, set in silver-gilt frame; 11.3 × 8.8cm (4½ × 3½in); signed and dated on verso: *Uppr. Charlotte St. Fitzroy Sqr. Painted by W.C. Ross 1823. Portrait of Isabella, Dowr. Viscountess Hawarden No.6*
COLLECTIONS: Christie's, London, 16 November 1976, lot 42
EXHIBITED: London (RA) 1824, no.684; Edinburgh 1999, pp.72–3, no.136

Although of Scottish origins, Sir William Charles Ross RA (1794–1860) was born in London. He showed artistic promise from an early age and became a pupil of his relative, the Scottish miniaturist Andrew Robertson. Ross exhibited his work regularly at the Royal Academy from 1809 onwards. He is known to have painted over 2,000 miniatures and was the greatest miniaturist of the nineteenth century. He painted most of the leading figures of the time and was a favourite artist of Queen Victoria, for whom he executed many portraits that still remain in the Royal Collection. He received a knighthood in 1842.

Anne Isabella Monck, sister of the 1st Viscount Monck, married Cornwallis Maude, 1st Viscount Hawarden as his third wife in 1777. This miniature is in exceptionally good condition and displays Ross's skill in painting a variety of textures as well as demonstrating his ability to grasp the sitter's personality.

CATALOGUE 59

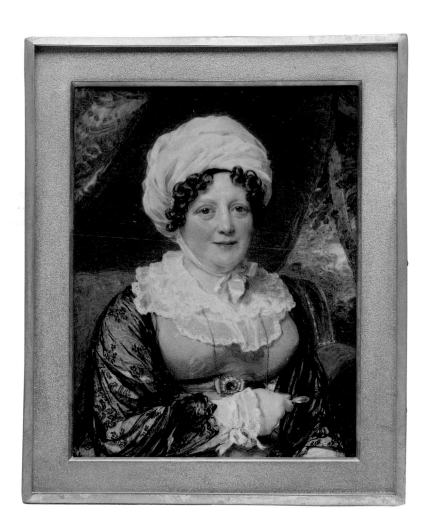

PLATE 18

# FREDERICK CRUICKSHANK

## *Unknown Gentleman c.1835*

Watercolour on ivory, set in a black rectangular wooden frame; 6.4 × 3.8cm (2½ × 1½in); signed on verso: F.C. *Taken in April*
COLLECTIONS: Sotheby's, Belgravia, 3 March 1977, lot 2 (then in original red leather travelling case)

Frederick Cruickshank (1800–1868) was born in Aberdeen and was a pupil of the Scottish miniaturist Andrew Robertson, whose influence can clearly be seen in his work. Cruickshank spent some time living and working in Manchester before moving to London. He married Catherine Daly, by whom he had six children, and the family lived in Portland Place in some style. He exhibited his miniatures regularly at the Royal Academy from 1822, and also continued to work in Scotland, regularly visiting country houses. Although Cruickshank's work is relatively scarce, his miniatures are identifiable for their bold, free style, which is expressive of the sitter's character.

CATALOGUE 61

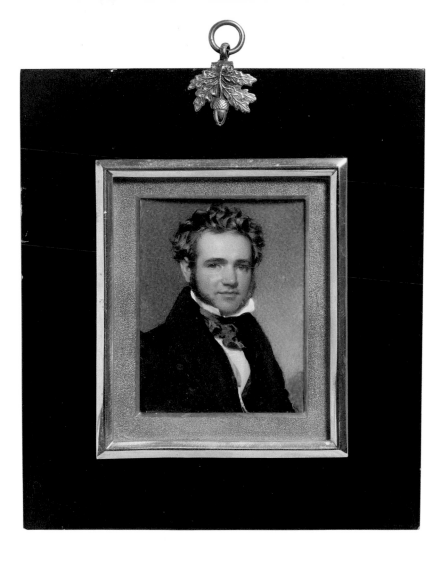

PLATE 19

## AARON EDWIN PENLEY

*Captain Charles Fanshawe* RN
*c.*1835

Watercolour on ivory, set in gilt-metal frame;
11.4 × 8.8cm (4½ × 3½in); inscribed on verso:
*Charles Fanshawe R.N. of Norwich. Painted by
James Leaky, 13 Southampton Street.*
COLLECTIONS: Purchased in 1978
REFERENCES: Foskett 1987, pp.276–7 and 279,
pl.70D

The inscription on the reverse of this miniature is partly erroneous. The highly delineated style of painting is very unlike that of James Leakey, who worked in his native Exeter as well as in London, and exhibited at the Royal Academy from 1821 to 1846. The style in this striking portrait of a naval officer is very similar to that of Aaron Edwin Penley (1807–1870), who practised as a miniaturist in Manchester (1834–5), then in Cheltenham, and finally from various addresses in London. He exhibited his work at the Royal Academy from 1835 to 1869. Penley was appointed watercolour painter in ordinary to William IV and also to the Dowager Queen Adelaide. Later in life, when he became a landscape painter, he was appointed professor of painting to the East India Company's military college at Addiscombe. This miniature is paired with a portrait of Mrs Charles Fanshawe [65], which is signed on the reverse by Penley.

CATALOGUE 64

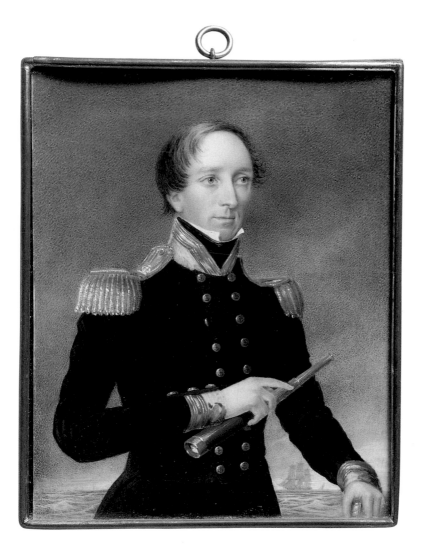

PLATE 20

## SIR WILLIAM CHARLES ROSS

*Baroness Howard de Walden and her Three Children* 1839

Watercolour on card, set in tortoiseshell frame;
20.2 × 15.3cm (8 × 6in)
COLLECTIONS: By family descent; purchased before 1984
REFERENCES: McKerrow 1982; Foskett 1984, p.28, fig.1; Edinburgh 2004, pp.70–1, col. pl.20
EXHIBITED: London (RA) 1839, no.889; London 1988, no.251, ill.

Lady Lucy Joan Cavendish Bentinck was the fourth daughter of the 4th Duke of Portland and sister of the eccentric 5th duke, from whom she inherited valuable property in Marylebone, London, which still belongs to her descendants. In 1828 she married Charles Augustus Ellis, 6th Baron Howard de Walden, who was a soldier and diplomat, and they had eight children together. It is the three eldest children who appear in this portrait: Frederick George, later 7th Baron Howard de Walden; Harriet Georgiana, who married Michael Angelo Caetani, duca di Sermoneta; and William Charles, who became a clergyman.

This group portrait was formerly attributed to John Faed, one of the most significant miniaturists and painters to work in Victorian Scotland. This work, a composition in watercolour on card, is very similar to the contemporary cabinet miniatures painted on ivory by Sir William Charles Ross RA (1794–1860). The Howard de Walden group with its complex composition, rich colouring and lavish detail is very like the large ivory by Ross of *Lady Augusta Hallyburton with Three of her Children*, painted in *c.*1840 (Christie's, London, 19 March 1986, lot 305 and see Foskett 1987, p.421, pl.126).

CATALOGUE 68

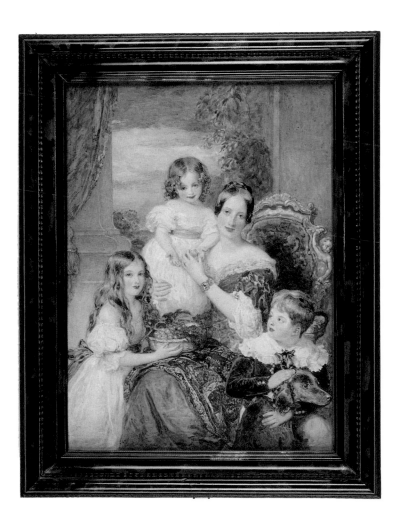

# CATALOGUE

**1** UNKNOWN ENGLISH SCHOOL
*Unknown Judge c.1560*

Oil on prepared card, set in a gold locket; 3.7cm (1½in) dia.
COLLECTIONS: Robert Bayne-Powell; purchased in 1973

Painted by an unknown artist, most probably working in England. This small portrait was made in the period after the death of Hans Holbein the Younger and Lucas Horenbout in the early 1540s, and before the emergence of Nicholas Hilliard in the early 1570s.

**2** SCHOOL OF FRANÇOIS CLOUET
*Unknown Gentleman c.1565*

Bodycolour on vellum, set in gilt-metal frame; 3.8cm (1½in) high
COLLECTIONS: Purchased in 1977

This finely detailed miniature was probably painted in France by an artist in the circle of François Clouet (1520?–1572). He was the son of Jean Clouet, whom he succeeded as court painter to Francis I, King of France in 1540. He continued in this post serving Henry II, Francis II and Charles IX of France. His miniatures can be dated from the early 1560s and show a pronounced mannerist influence. François Clouet's portrait drawings and miniatures had a considerable influence on Nicholas Hilliard's development when he came into contact with them during his stay in France during the late 1570s.

**3** NICHOLAS HILLIARD
*Queen Elizabeth (1533–1603) c.1575*

See pages 16 and 17

**4** NICHOLAS HILLIARD
*Robert Dudley, Earl of Leicester (1532–1588) c.1575*
See pages 16 and 17

**5** SAMUEL COOPER
*James, 12th Earl and later 1st Duke of Ormonde
(1610–1688) 1647*
See pages 18 and 19

**6** RICHARD GIBSON
*Anne Hyde, Duchess of York (1637–1671) c.1662*
See pages 20 and 21

**7** CHARLES BEALE 'THE YOUNGER'
*Charles Taylor 1689*
See pages 22 and 23

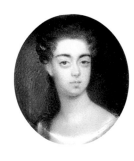

**8** PETER CROSS
*Unknown Lady c.1690*
Bodycolour on vellum, set in silver gilt locket; 2.5cm (1in) high
COLLECTIONS: Christie's, London, 12 November 1974, lot 47

For many years Peter Cross (c.1645–1724) was confused with another miniaturist, a mythical son called Lawrence Crosse, owing to a misreading of his monogrammed signature. Examples of his miniatures occur from the early 1660s and he enjoyed a prolific career in London. In 1676 he succeeded Nicholas Dixon as limner in ordinary to Charles II. Cross was also well known as a collector and connoisseur of portrait miniatures, acquiring for his cabinet works by John Hoskins and Samuel Cooper. His collection was sold at auction in 1722.

**9** CHRISTIAN RICHTER
*Unknown Lady Holding a Dove c.1705*
See pages 24 and 25

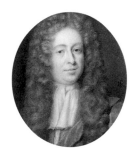

**10** CHRISTIAN RICHTER

*Unknown Gentleman c.1710*

Bodycolour on vellum stuck on plain card, set in silver scroll-topped frame; 6.3cm (2½in) high; signed on recto: *C.R.*
COLLECTIONS: Purchased in 1972
REFERENCES: Foskett 1987, p.155, pl.35G

This is a rare instance of a miniature by Richter that is signed on the front. It also represents a fine example of the artist's softly stippled style of painting.

**11** BENJAMIN ARLAUD

*Unknown Gentleman c.1715*

See pages 26 and 27

**12** BERNARD LENS

*William Whitmore (1682–1725) 1718*

See pages 28 and 29

**13** BERNARD LENS

*Elizabeth Pope, Mrs William Whitmore (1681–1735) and her son Charles (1716–1770) 1716*

See pages 30 and 31

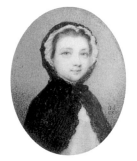

**14** GERVASE SPENCER

*Lady Louisa Greville 1751*

Watercolour on ivory, set in black turned wooden frame; 3.8cm (1½in) high; signed and dated on recto: *G.S. / 1751*; inscribed on verso: *Lady Louisa / Churchill / Col. Greville's / sister / 1751*
COLLECTIONS: The Earl Cathcart; Sotheby's, London, 25 June 1979, lot 103; Sotheby's, London, 24 October 1988, lot 286

Lady Louisa Greville, who is depicted here as a young girl, was the daughter of Francis Greville, 1st Earl of Warwick and 1st Earl Brooke,

and his wife Elizabeth Hamilton, a sister of Sir William Hamilton, the distinguished British ambassador in Naples. The sitter married William Churchill of Henbury, Dorset, in 1770. The 'modest school' miniaturist and enameller Gervase Spencer (fl.1740–63) was possibly taught by André Rouquet, a Geneva Protestant who was then resident in London. Spencer exhibited some of his miniatures at the Society of Artists in 1761 and 1762.

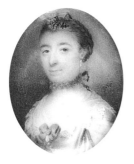

### 15 SAMUEL COLLINS
### *Unknown Lady* 1759

Watercolour on ivory, set in gold bracelet frame; 3.8cm (1½in) high; signed and dated on recto: *s.c. / 1759*
COLLECTIONS: A.E. Day; Christie's, London, 25 November 1987, lot 370

Samuel Collins (*c.*1735–1768) was born in Bristol, the son of a clergyman. He established a successful practice as a 'modest school' miniaturist in fashionable Bath, where his pupil was the successful miniaturist Ozias Humphry. However, Collins's extravagance led him into debt and in 1762 he fled to Dublin to avoid his creditors. He worked there productively until his death.

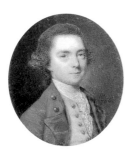

### 16 NATHANIEL HONE
### *Sir Thomas Wynn* 1766

Watercolour on ivory, set in gold locket frame; 3.8cm (1½in) high; signed and dated on recto: *n.h. / 1766*
COLLECTIONS: E. Grosvenor Paine; his sale, Christie's, London, 28 October 1980, lot 113; Christie's, London, 20 March 1990, lot 126

The third son of Nathaniel Hone, a merchant in Dublin, the young artist moved to England and practised as an itinerant portraitist. In 1750 he travelled to Rome and two years later became a member of the Florentine Academy. Settling in London, Hone exhibited his work at the Society of Artists from 1760 to 1768. In 1769 he became a founder member of the Royal Academy and continued exhibiting there until his death. Nathaniel Hone painted high quality miniatures on ivory and in enamels during the earlier part of his career. Among his ten children was the miniaturist Horace Hone.

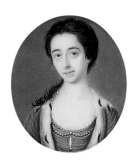

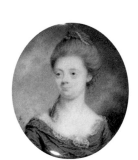

**17** JAMES SCOULER

*Unknown Lady* 1768

Watercolour on ivory, set in silver-gilt locket frame; 3.8cm (1½in) high; signed on recto: *J. Scouler*; inscribed by the artist on verso: *This paper / must not be / taken off / 1768.*
COLLECTIONS: Sotheby's, London, 13 July, 1982, lot 113; Sotheby's, London, 28 April 1988, lot 93
EXHIBITED: Edinburgh 1999, p.56, no.22

James Scouler (*c.*1740–1812) was born in Edinburgh, the son of an organ builder and music shop proprietor. He studied in London at the St Martin's Lane Academy and in 1775 won a premium for drawing at the Society of Arts. He exhibited his work at the Society of Artists from 1761 to 1768 and at the Royal Academy from 1780 to 1787. Scouler's meticulously stippled miniatures were much sought after and he left an estate of around £7,500 at his death. His portraits are characterised by a confident application of gum Arabic and a 'direct masculine style', reminiscent of his contemporary, John Smart.

**18** LUKE SULLIVAN

*Unknown Lady* 1769

Watercolour on ivory, set in gold locket frame; 4.4cm (1¾in) high; signed and dated on recto: *L.S. / 1769*
COLLECTIONS: E. Grosvenor Paine; Christie's, London, 23 October 1979, lot 97; Christie's, London, 13 December 1983, lot 151

Luke Sullivan (1705–1771), born in Co. Louth in Ireland, moved to England when his father became a groom to the Duke of Beaufort. He spent his career in England, initially working as an assistant to Hogarth and the engraver Le Bas. He exhibited his modest but sophisticated work at the Society of Artists, of which he was a member, from 1764 to 1771.

**19** OZIAS HUMPHRY

*Unknown Boy c.*1770

Watercolour on ivory, set in gold bracelet frame; 3.7cm (1½in) high
COLLECTIONS: Purchased in 1988

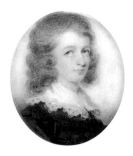

The son of a Devonian wig-maker and mercer, Ozias Humphry (1742–1810) was sent to London in 1757, where he studied at the St Martin's Lane Academy. In 1760 he was apprenticed to the miniaturist Samuel Collins in Bath, and two years later he succeeded to his master's practice. He exhibited his work at the Society of Artists from 1765 to 1771, and later visited Italy with Romney (1773–7). After returning to London he showed his work at the Royal Academy (1779–97), to which he was elected in 1791. He made an unsuccessful visit to India (1785–7), where various clients failed to pay for work completed. In later life his eyesight began to fail and he turned to painting in crayons and occasionally in oils.

### 20  JEREMIAH MEYER

## Unknown Gentleman *c*.1775

Watercolour on ivory, set in gold bracelet frame; 3.7cm (1½in) high
COLLECTIONS: E. Grosvenor Paine; Christie's, London, 28 October 1980, lot 63

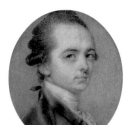

Born in Tübingen, Jeremiah Meyer (1735–1789) was brought to England about 1749 by his father, who was portrait painter to the Duke of Württemburg. He studied at the St Martin's Lane Academy and also with the miniaturist Christian Friedrich Zincke (1683/4–1767), and he soon established himself as a portrait miniaturist in both watercolour and enamel. He exhibited his work at the Society of Artists (1760–7), and in 1764 he was appointed miniature painter to Queen Charlotte and painter in enamel to George III. Meyer became a founder member of the Royal Academy and exhibited his work there from 1769 to 1783.

### 21  RICHARD CROSSE

## Unknown Lady *c*.1775

Watercolour on ivory, set in gold locket frame; 4.5cm (1½in) high
COLLECTIONS: Purchased in 1987

Richard Crosse (1742–1810), who was born a deaf mute, lived at Knowle near Cullompton in Devon. He moved to London to study at William Shipley's drawing school, where he won a premium at the Society of Arts in 1758. Crosse exhibited his miniatures at the Society of Artists between 1760 and 1791, as well as at the Free Society of Artists from 1761 to 1768.

He also showed his work at the Royal Academy from 1770 to 1796. He was appointed painter in enamel to George III in 1788, succeeding Jeremiah Meyer, and portrayed in miniature various members of the royal family. Crosse's miniature painting box survives (Victoria & Albert Museum, London) as does his manuscript ledger for work completed between 1775 and 1798 (National Art Library, Victoria & Albert Museum, London). He died at Cullompton in 1810.

### 22 SAMUEL COTES
### Mrs. Yates (c.1728–1787) 1776

See pages 32 and 33

### 23 JOHN SMART
### Joseph Sage 1780

Watercolour on ivory, set in gold bracelet frame; 3.8cm (1½in) high; signed and dated on recto: *J.S. / 1780*; inscribed on verso: *Mrs. Arthur Shakespear* [sic] */ A most valuable present from / her very Dearest Mother, being / the likeness of her beloved Father / when young.*
COLLECTIONS: Mrs Arthur Shakespeare; Sotheby's, London, 8 June 1987, lot 115
REFERENCES: Foskett 1964, p.73

John Smart (1742/3–1811) was – together with Richard Cosway – one of the two outstanding portrait miniaturists of the late eighteenth century. He exhibited his highly realistic work in London from 1762 until his death. Smart enjoyed a successful ten-year period in India from 1785, during which he signed his miniatures with an 'I' (for India).

The sitter, Joseph Sage, was the father of Mrs Arthur Shakespeare, whose husband, a Member of Parliament, was painted by Smart in 1787.

### 24 ARCHIBALD SKIRVING
### Unknown Lady c.1780–5

Watercolour on ivory, set in gold locket frame; 7.6cm (3in) high
COLLECTIONS: Sotheby's, London, 12 March 1984, lot 155; Christie's, London, 23 May 1989, lot 111
EXHIBITED: Edinburgh 1999, p.58, no.31

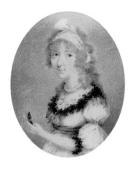

Archibald Skirving (1749–1819), the son of a Jacobite farmer, was born near Haddington in East Lothian. After training as an artist in Edinburgh he produced portraits in oil and in miniature. Following an unsuccessful period in London from 1777 to 1784, he returned to Edinburgh, where he began to work in pastels, a medium in which he excelled. From 1787 to 1794 Skirving studied and worked in Italy. After returning to Edinburgh in 1795, Skirving re-established his practice as a pastellist, before retiring as a professional artist in 1803. In his later years the artist produced finely detailed portrait drawings in profile. This miniature of an unknown lady holding a mask is particularly close in style, composition and date to the miniature of an 'Unknown Lady' – signed and dated 1780 – in the Victoria & Albert Museum, London (see Edinburgh 1999, p.16, fig.9).

**25** JOSEPH DANIEL
*Unknown Gentleman Holding a Glass of Water* c.1780–5
See pages 34 and 35

**26** JOHN BOGLE
*Unknown Gentleman* 1782
See pages 36 and 37

**27** RICHARD COSWAY
*Charlotte, Baroness de Ferrars, later Countess of Leicester (d.1802)* c.1785

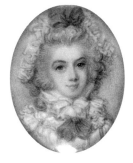

Watercolour on ivory, set in silver frame with pastes; 5.1cm (2in) high
COLLECTIONS: Sotheby's, London, 9 June 1986, lot 189

Charlotte was the second daughter and co-heiress of Eaton Mainwearing-Ellerker of Risby Park, Yorkshire. In 1777 she married George, Baron de Ferrars of Chartley, the eldest son of George, 1st Marquess Townshend by his first wife, Charlotte Compton, Baroness de Ferrars. Baron de Ferrars was created Earl of Leicester in 1784, and succeeded as 2nd Marquess Townshend in 1807, dying in 1811. As Charlotte died in 1802, she never became Marchioness Townshend. She had five children. The artist, Richard Cosway (1742–1821), was the

leading miniaturist to fashionable society during the Regency period. This is a typically flattering portrayal of a female sitter, painted at the time that the artist became the principal painter to the Prince of Wales.

**28** SAMUEL SHELLEY
*A Family Group: an Unknown Gentleman and Two Ladies*
c.1785

See pages 38 and 39

**29** CHARLES SHIRREFF
*Unknown Officer* c.1785

See pages 40 and 41

**30** HORACE HONE
*Ellen O'Brien, Mrs Edmund O'Callaghan* 1785

See pages 42 and 43

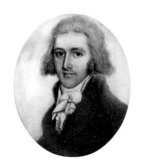

**31** JOHN BARRY
*Unknown Gentleman* c.1785–90

Watercolour on ivory, set in silver-gilt frame with hair on verso; 6.4cm (2½in) high
COLLECTIONS: Purchased in 1986

John Barry (fl.1784–1827) worked in London, and exhibited at the Royal Academy from 1784 to 1827. He may have been the 'John Barry, bachelor', who married Elizabeth Screech at St Mary-le-bone on 4 October 1792. His painting style is characterised by angular eyebrows, nearly vertical brushstrokes on the faces, and brownish shading. He rarely signed his work, and his style is also reminiscent of that of Thomas Hazlehurst.

**32** MRS DIANA HILL (NÉE DIETZ)
*Sir Charles Cockerell, Bt (1755–1837)* 1786

See pages 44 and 45

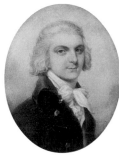

### 33 PHILIP JEAN
## *Unknown Gentleman c.1790*

Watercolour on ivory, set in gold locket frame with verso of blue glass; 6.3cm (2½in) high
COLLECTIONS: E. Grosvenor Paine; Christie's, London, 28 October 1980, lot 128

Philip Jean (1755–1802) was born at St Ouen, Jersey. As a young man he served in the navy under Admiral Rodney. Jean exhibited his works, which were mainly miniatures, at the Royal Academy in London from 1787 until his death. He received various commissions from members of the royal family. A prolific miniaturist who sustained a high level of quality in his work, Jean's style is closest to that of Richard Cosway and Samuel Shelley.

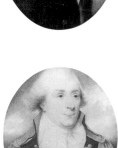

### 34 GEORGE PLACE
## *Captain R. Bartlett c.1790–5*

Watercolour on ivory, set in gold locket frame, the verso with a seed pearl monogram *RB* over pleated hair; 7.6cm (3in) high
COLLECTIONS: by family descent; Christie's, London, 8 July 1987, lot 356; Christie's, London, 25 November 1987, lot 327

George Place (*c.*1763–1805) was born in Dublin, the son of a wholesale linen draper. He entered the Dublin Society schools in 1775, and practised as a miniaturist in Dublin until 1791, when he moved to London. He exhibited at the Royal Academy from 1791 to 1797. Together with Sampson Towgood Roch and Adam Buck, Place was one of the most accomplished Irish artists to work in England during the 1790s. Like his fellow Irish miniaturists, Samuel Andrews and George Chinnery, Place went to work in India, and established himself at Lucknow in 1798. Captain Bartlett, shown wearing the uniform of the Royal Artillery, was the brother of Jane Bartlett, Lady Dunbar.

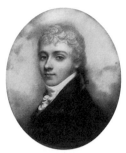

### 35 ANDREW PLIMER
### *Unknown Gentleman c.1795*

Watercolour on ivory, set in gold locket frame with verso of hair; 7.6cm (3in) high
COLLECTIONS: Sotheby's, London, 8 June 1987, lot 121

The son of a clock maker, Andrew Plimer (1763–1837) and his elder brother, Nathaniel, who also became a miniaturist, were apprenticed to their father's trade. On arrival in London during 1781, Andrew found employment as a manservant to the fashionable artist Richard Cosway, who gave him lessons. In 1785 Plimer established his own portrait practice and he exhibited his work at the Royal Academy from 1786 to 1830. A prolific miniaturist, Plimer's style is very distinctive with its restricted palette, his treatment of his sitters' eyes and idealised portrayal.

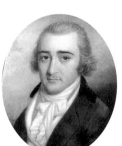

### 36 THOMAS HAZLEHURST
### *Unknown Gentleman c.1795*

Watercolour on ivory, set in gold locket frame with blue glass on verso; 6.3cm (2½in) high; signed on recto: *T.H.*
COLLECTIONS: Purchased in 1987

Thomas Hazlehurst (*c.*1740–1821) was born in Liverpool, where he practised as a miniaturist for almost his entire working life. He exhibited at the Society for Promoting Painting and Design in Liverpool (1787) and at the Liverpool Academy (1810–12). Hazlehurst's early work shows the influence of Charles Robertson, while his later production is similar to that of John Barry.

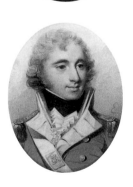

### 37 GEORGE ENGLEHEART
### *Lt Col. Thomas Gray (d.1797) 1796*

Watercolour on ivory, set in gold locket frame with plaited hair on verso; 7.6cm (3in) high
COLLECTIONS: H. Gordon Bois; Sotheby's, London, 27 March 1947, lot 127; Sotheby's, London, 20 January 1975, lot 47; Christie's, London, 23 March 1982, lot 299

In this miniature the sitter is shown wearing the uniform of the 12th Regiment of Foot, which later became the Suffolk Regiment. At least

three other versions of this miniature are known, one of which is probably a later copy. One version has an inscription on the frame stating that Gray died at the Cape of Good Hope on 17 January 1797, aged twenty-six. The sitter is recorded as having sat to Engleheart in 1796. His name also appears in Engleheart's fee book for 1797, which must refer to the copies made for his grieving family. George Engleheart (1750/5–1829) was one of the finest miniaturists of the late eighteenth and early nineteenth century, and exhibited his work at the Royal Academy from 1773 to 1822.

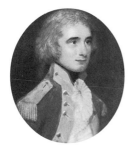

### 38  SAMUEL ANDREWS
### *Major Paul Bose (d.1808) c.1799*

Watercolour on ivory, set in silver-gilt frame with verso of hair and blue glass; 6.4cm (2½in) high
COLLECTIONS: Christie's, London, 22 March 1988, lot 295

An Irishman, Samuel Andrews (1767?–1807) travelled to Madras in 1791. He is probably the Samuel Andrews who, in July 1795, married Janetta Christina Elbracht. That same year he moved into a house in Madras that was formerly occupied by the miniaturist John Smart, who had recently returned to England. Andrews moved to Calcutta in 1798 and died at Patna. Paul Bose's military career began as a cadet in 1781, and he was promoted to lieutenant in 1790. He married in 1792 and three years later was appointed adjutant in the 2nd Battalion of the Madras European Infantry. In 1799, when this miniature was painted, Bose became a captain in the 14th Madras Native Infantry, and was promoted to major in 1805. He died three years later at Vellore.

### 39  CHARLES ROBERTSON
### *Unknown Gentleman c.1800*

Watercolour on ivory, set in silver-gilt frame, with hair on verso; 6.3cm (2½in) high
COLLECTIONS: Sotheby's, London, 4 July 1983, lot 144

Charles Robertson (c.1760–1821) was born in Dublin, the son of a jeweller, and the younger brother of the miniaturist Walter Robertson. Charles worked in Dublin until his first major visit to London from 1785 to 1792. He exhibited his work both at the Royal Academy in London from 1790 to 1810, and in Dublin up until his death in that city. Robertson was secretary

of the Hibernian Society of Artists and became its vice-president in 1814. His miniatures are of a high quality and are delicately painted with soft modelling for the facial features. He did not sign his work.

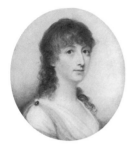

### 40 WALTER ROBERTSON
### *Unknown Lady c.1800*

Watercolour on ivory, set in gold locket frame with blue glass and hair on verso; 6.3cm (2½in) high
COLLECTIONS: Sotheby's, London, 28 April 1988, lot 50

Walter Robertson (d.1801) was the son of a Dublin jeweller and the elder brother of the miniaturist Charles Robertson. Walter entered the Dublin Society schools in 1765 and exhibited his work publicly in Dublin from 1769 to 1777. He moved to London around 1784 and practised there for a few years. After returning to Dublin he was declared bankrupt in 1792. The following year he travelled to America with the oil portraitist Gilbert Stuart, where he was known as 'Irish Robertson'. He left America for India in 1795 where he died. This portrait is likely to have been painted in India towards the end of the artist's life.

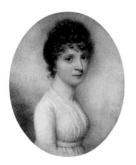

### 41 WILLIAM WOOD
### *Unknown Lady c.1800*

Watercolour on ivory, set in gold locket frame with hair on verso; 7.6cm (3in) high; inscribed inside: *Will. Wood / of Cork Street / London*
COLLECTIONS: Sotheby's, London, 8 June 1987, lot 137

William Wood (1769–1810) was born in Suffolk. He entered the Royal Academy schools in 1785, and exhibited his work at the Royal Academy and the British Institution between 1788 and 1808. He is known to have copied miniatures by Smart, Engleheart and Cosway, while his style was closest to that of Cosway. Many of his miniatures are signed in full inside. His ledger books survive in the National Art Library (Victoria & Albert Museum, London).

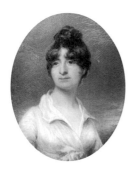

**42** JOHN WRIGHT

## *Deborah Williams, Mrs Walter Tremenheere c.1803–4*

Watercolour on ivory, set in gold locket frame with blue glass on verso; 7.6cm (3in) high; signed inside on verso: *J. Wright / Leicester Sqr. / Soho.*
COLLECTIONS: Purchased in 1987

The sitter was born in Cornwall and was the daughter of the Revd Anthony Williams. She married Sir Walter Tremenheere, a distinguished naval officer, who was born in Penzance. He was lieutenant-governor of Curaçao, colonel-commandant of the Chatham division of the Royal Marines, and briefly aide-de-camp to William IV, for which he was made a knight of Hanover. The couple had two sons, both of whom were soldiers in India. This miniature, which can be dated in 1803–4 (on account of that being the year that the artist resided in Soho), may be a marriage portrait. Little is known of the early life and career of John Wright (fl.1795–1820), except that he was known as a copyist. He also exhibited his work at the Royal Academy from 1795 to 1819. His first wife died in childbirth and he committed suicide.

**43** HENRY EDRIDGE

## *Unknown Lady c.1805*

Watercolour on ivory, set in sliver-gilt frame with blue glass verso; 7.6cm (3in) high
COLLECTIONS: Christie's, London, 19 June 1973, lot 90

Henry Edridge (1768–1821) was the son of a Westminster tradesman and was apprentice to the engraver William Pether. He entered the Royal Academy schools in 1784 and two years later was awarded a silver medal. Edridge exhibited at the Royal Academy from that year until his death, and was elected an associate in 1820.

**44** ALEXANDER GALLAWAY

## *Mrs Mary Robertson 1809*

See pages 46 and 47

**45** NATHANIEL PLIMER
*Unknown Gentleman ('M.E.') c.1810*

Watercolour on ivory, set in gold locket frame with verso of hair and monogram *ME* in seed pearls; 6.3cm (2½in) high
COLLECTIONS: Purchased in 1989

Nathaniel Plimer (1757–1822), was born in Wellington, Somerset, and was the younger brother of the better-known miniaturist Andrew Plimer. Nathaniel may have taken lessons with Richard Cosway. He exhibited his work at the Royal Academy from 1787 to 1815 and is recorded as living in Edinburgh from 1804/5 to 1813/14. One of his daughters, Adela, married the Scottish painter and printmaker Andrew Geddes.

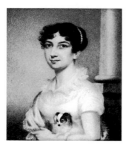

**46** SAMPSON TOWGOOD ROCH
*Unknown Lady c.1810*

Watercolour on ivory, set in black acorn frame; 7.6 × 5.1cm (3 × 2in)
COLLECTIONS: Sotheby's, London, 17 July 1973, lot 88

An Irishman, Sampson Towgood Roch (1759–1847), or Roche, was born a deaf mute. He trained in Dublin and was active there from 1784 to 1792, when he moved to Bath. There, Roch developed a flourishing business, painting members of the royal family including Princess Amelia. He died at Woodbine Hill in Co. Waterford. He signed his miniatures either 'Roch' or 'Roche'.

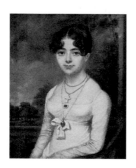

**47** WALTER STEPHENS LETHBRIDGE
*Unknown Lady (d.1813) 1812*

Watercolour on ivory, set in black acorn frame; 8.8 × 6.3cm (3½ × 2½in); inscribed on verso: *Taken 1812, / died 1st May 1813.*
COLLECTIONS: Purchased in 1975

Walter Stephens Lethbridge (1772–1831?) was born at Charlton in Devon. Little is known of his early life and career, although he exhibited his work publicly in London from 1801. It is known that Lethbridge worked in Canterbury as the artist placed the following advertisement in the *Kentish Gazette* on 27 August 1805: 'Likenesses painted in miniature. Mr Lethbridge is just arrived in Canterbury. Price 3 guineas & upwards.' He

retired to Plymouth in 1831, the year in which he is thought to have died. This miniature was formerly attributed to Charles Foot Tayler.

## 48 JOHN COX DILLMAN ENGLEHEART
### *Unknown Lady* 1814

Watercolour on ivory, set in chiselled ormolu frame; 12.7 × 10.2cm (5 × 4in); signed on verso: *John Cox Dillman Engleheart / Pinxit 1814 London.*
COLLECTIONS: Mrs K.H. Ascoll; Christie's, London, 14 December 1971, lot 52
REFERENCES: Foskett 1987, p.408, pl.119E

John Cox Dillman Engleheart (1782/4–1862) was the nephew of the prolific miniaturist George Engleheart, and became his pupil. He entered the Royal Academy schools in 1800, and exhibited his work at the Academy between 1801 and 1828, when he appears to have stopped painting miniatures.

## 49 ALFRED EDWARD CHALON
### *Mrs Dudley Ryder c.*1820

Watercolour on ivory, set in ormolu frame; 8.8 × 6.4cm (3½ × 2½in); signed on recto: *A. Chalon*
COLLECTIONS: Purchased in 1972

Alfred Edward Chalon (1780–1860) was born in Geneva of French descent. Having been brought to England by his father in 1789, he entered the Royal Academy schools in 1789. He exhibited his work publicly at the Royal Academy from 1801 and enjoyed an immensely successful career. Chalon was patronised by the royal family and Queen Victoria sat for him, later appointing him as her painter in watercolour. In 1808 he became a member of the Associated Artists in Watercolours. Chalon was elected an associate of the Royal Academy in 1812 and a full academician in 1816. No details of the sitter are known but it seems likely that she was a member of the Ryder family from Leicestershire.

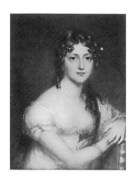

**50** MRS ANNE MEE (NÉE FOLDSONE)

*Mrs Taylor c.*1820

Watercolour on ivory, set in ormolu frame; 11.3 × 8.8cm (4½ × 3½in)
COLLECTIONS: Sotheby's, London, 16 July 1973, lot 36
REFERENCES: Foskett 1984, p.44, ill.

Anne Foldsone (c.1770/5–1851) was the daughter of the London-based
artist and copyist John Foldsone. She was introduced to Queen Charlotte
by Lady Courtown, and by 1791 she was undertaking royal commissions
at Windsor Castle. She also received generous patronage from the Prince
of Wales (later the Prince Regent and George IV), who commissioned
her to paint in miniature the fashionable ladies of the court, known as
the 'Gallery of Beauties of George III', in 1812–13. Foldsone married
Joseph Mee, an Irishman, in 1804.

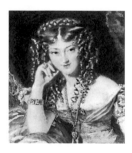

**51** ALFRED EDWARD CHALON

*Miss Roper* 1825

Watercolour on ivory, set in gilt-metal frame; 8.8 × 6.4cm (3½ × 2½in);
signed on verso: *Painted by / Alfd. Edwd. Chalon R.A. / London 1825 /
Portrait of Miss Roper, / niece of Lord Teynham*
COLLECTIONS: Holzsheiter; Sotheby's, London, 28 March 1977, lot 46

**52** ALFRED EDWARD CHALON

*Unknown Officer c.*1825

Watercolour on ivory, set in black acorn frame; 7.6 × 5.1cm (3 × 2in);
signed on recto: *A.E.C.R.A.*
COLLECTIONS: Sotheby's, London, 10 June 1974, lot 56

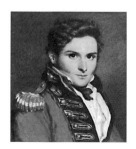

**53** SIMON-JACQUES ROCHARD

*Unknown Lady* 1825

Watercolour on ivory, set in ormolu frame; 11.4 × 8.8cm (4½ × 3½in);
signed on recto: *Rochard 1825*
COLLECTIONS: Purchased in 1972

Simon-Jacques Rochard (1788–1872) was born in Paris and was the elder

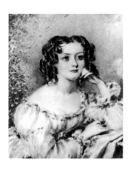

brother of the miniaturist François-Théodore Rochard (1798–1858). He entered the Académie de Beaux-Arts, Paris, in 1813. Two years later he travelled to Brussels to escape conscription, and there he painted the Duke of Wellington. In 1816 he arrived in London and embarked upon a highly successful career, exhibiting regularly at the Royal Academy and elsewhere until 1845. The following year he settled in Brussels and showed his work at the Salon there until 1869.

**54** ALFRED EDWARD CHALON

*Sarah Sophia, Countess of Jersey (1785–1867) c.1825*

Watercolour on ivory, set in ormolu frame; 10.2 × 7.6cm (4 × 3in)
COLLECTIONS: Sotheby's, London, 18 November 1972

Lady Sarah Sophia Fane was the daughter of John, 10th Earl of Westmorland and his first wife, Sarah Anne, daughter and heiress of the banker Robert Child. In 1804 Sarah Sophia married George Villiers, 5th Earl of Jersey who, when his wife inherited her grandfather's fortune, added the name of Child to his own. They had six children.

**55** STEPHEN POYNTZ DENNING

*Unknown Gentleman c.1825*

Watercolour on ivory, set in black turned wooden frame; 13.9cm (5½in) high; signed on recto: *S.P.D.*
COLLECTIONS: Sotheby's, London, 17 November 1973, lot 89
REFERENCES: Foskett 1987, p.420, pl.125D

Stephen Poyntz Denning (1795–1864), who was said to have come from very humble origins, was a pupil of John Wright. Denning exhibited his work at the Royal Academy and elsewhere in London from 1814 to 1852, and was appointed as curator of the Dulwich Picture Gallery in 1821. His miniatures often have an affinity to those of Alfred Edward Chalon.

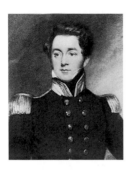

**56** CHARLES RICHARD BONE

## *Captain Richard H. King* 1830

Watercolour on ivory, set in silver-gilt frame; 12.7 × 10.6cm (5 × 4in); signed and dated on recto: *C.R.B. 1830*; inscribed on the verso: *Portrait of Capt. R.H. King, R.N. / Painted by C.R. Bone, / 47, Charlotte Street, Portland Place, / London 1830.*
COLLECTIONS: Christie's, London, 18 December 1974, lot 41
REFERENCES: Foskett 1987, p.402, pl.116A

Charles Richard Bone (1809–c.1880) was the son of the enameller Henry Pierce Bone and the grandson of the more famous enameller Henry Bone RA. He entered the Royal Academy schools in 1828, and exhibited his work at the Academy and elsewhere until 1848. C.R. Bone visited Rome in 1832–3. He painted both on ivory and in enamels. The sitter, Richard King, was the sixth son of a Suffolk parson and joined the Navy in 1805.

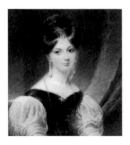

**57** THOMAS HARGREAVES

## *Unknown Lady c.*1830

Watercolour on ivory, set in ormolu frame; 10.2 × 7.6cm (4 × 3in)
COLLECTIONS: Purchased in 1973

Thomas Hargreaves (1774–1846/7) was born in Liverpool and was the son of a woollen-draper. After entering the Royal Academy schools in 1790 he became assistant to Sir Thomas Lawrence. Hargreaves returned to work in Liverpool in 1795, exhibiting his work intermittently in London and Liverpool from 1798 to 1835. Hargreaves's oeuvre is of a high quality and the influence of Lawrence is marked. Nearly 800 of his compositional drawings for miniatures are preserved in the Local History Department of the Liverpool City Library.

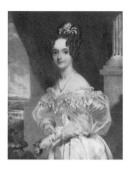

### 58 ANDREW ROBERTSON
## *Unknown Lady c.1830*

Watercolour on ivory, set in ormolu frame; 10.2 × 7.6cm (4 × 3in)
COLLECTIONS: E.V. Hickson; Sotheby's, London, 6 October 1969, lot 69;
purchased in 1973

Andrew Robertson (1777–1845) was born in Aberdeen, the son of architect
William Robertson. His two elder brothers, Archibald and Alexander,
also worked as miniaturists. After studying with Raeburn and Nasmyth in
Edinburgh, Andrew Robertson entered the Royal Academy schools in
1801. He exhibited his work regularly at the Academy and enjoyed an
immensely successful career, being appointed miniature painter to the
Duke of Sussex in 1805. Among his pupils were the miniaturists Frederick
Cruickshank and Sir William Charles Ross. One of his own sons, Edward,
was also an accomplished miniaturist. The Scottish National Portrait
Gallery has recently acquired over two hundred of Robertson's prepara-
tory drawings, which are studies for his portrait miniatures.

### 59 SIR WILLIAM CHARLES ROSS
## *Isabella, Dowager Viscountess Hawarden 1824*

See pages 48 and 49

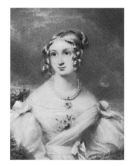

### 60 MARIA A. CHALON (LATER MRS HENRY MOSELEY)
## *Mary Deverill (later Mrs Deshon) c.1835*

Watercolour on ivory, set in ormolu frame; 11.4 × 8.8cm (4½ × 3½in);
inscribed on verso: *Miss Deverill / by Maria Chalon / 1835*
COLLECTIONS: Christie's, London, 27 March 1979, lot 27

Maria A. Chalon (*c.*1800–1867) was the daughter of Henry Barnard
Chalon, the animal painter. Working in London, she exhibited her
miniatures at the Royal Academy from 1819 to 1840 under her maiden
name, and from 1841 to 1866 under her married name. Her husband,
Henry Moseley, was a portrait painter. She became 'portrait paintress' to
the Duke of York in *c.*1823. The sitter, Miss Deverill, married Major D.F.
Deshon.

**61** FREDERICK CRUICKSHANK
*Unknown Gentleman c.*1835

See pages 50 and 51

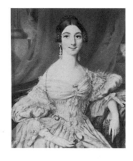

**62** LORENZO THEWENETI
*Unknown Lady c.*1835

Watercolour on ivory, set in ormolu mount within black acorn frame; 11.4 × 8.9cm (4½ × 3½in); signed on recto: *L.T.*
COLLECTIONS: Purchased in 1974
REFERENCES: Foskett 1987, p.266, pl.65D

Lorenzo Theweneti (*c.*1797–1878) was of Italian origin and worked in Cheltenham in 1824 before moving to Bath, where he spent much of his career, in 1829. He exhibited at the Royal Academy from 1824 to 1831. He and his two brothers, Edward and Michael, were also drawing masters and landscape painters, later becoming photographers.

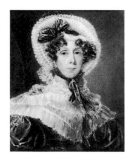

**63** EDWARD WILLIAM THOMSON
*Betty Wallis, Mrs Samuel Stephens* 1836

Watercolour on ivory, set in black acorn frame; 10.2 × 7.6cm (4 × 3in); signed on recto: *E.W.T.*; inscribed on verso: *E.W. Thomson pinxt 1836. / 69 Berner Street, Oxford St. / 6 Argyll St. / Betty Stephens, née Wallis, wife of Samuel Stephens of Tregenna Castle, Cornwall.*
COLLECTIONS: Sotheby's, London, 26 February 1973, lot 20

Edward William Thomson (1770–1847) started his career as an engraver before becoming miniature painter. He exhibited his work at the Royal Academy from 1832 to 1839. Some of his miniatures show the influence of Jean-Baptiste Isabey and Alfred Edward Chalon. Thomson is known to have worked in Paris from about 1824 to 1830. He died in Lincoln.

**64** AARON EDWIN PENLEY
*Captain Charles Fanshawe* RN *c.*1835

See pages 52 and 53

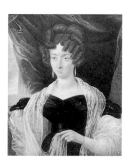

### 65 AARON EDWIN PENLEY
## *Mrs Charles Fanshawe c.*1836

Watercolour on ivory, set in brass frame; 11.4 × 8.8cm (4½ × 3½in);
signed on reco: *Penley*
COLLECTIONS: Purchased in 1974
REFERENCES: Foskett 1987, p.279, pl.70D

The sitter was the wife of Charles Fanshawe, a naval captain from
Norwich, who was also painted around this date by Penley.

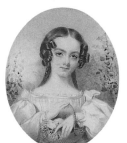

### 66 CHARLES FOOT TAYLER
## *Eleanor Ann Ram, Mrs Archibald Campbell (d.1879)* 1837

Watercolour on ivory, set in rectangular frame; 8.8cm (3½in) high;
signed and dated on verso: *Painted by C. Foot Tayler, / 8 Oxford Row,
Bath, / 1837.*
COLLECTIONS: Christie's, London, 18 April 1972, lot 71
REFERENCES: Foskett 1984, p.43, ill.

Little is known of the origins of Charles Foot Tayler (fl.1818–1853) prior
to 1818, when he was awarded a silver medal by the Society of Arts. In
1820–1 he was living on the Isle of Wight and he settled in Bath from 1822,
where he had a successful portrait practice. He exhibited his work at the
Royal Academy from 1820 until his death.

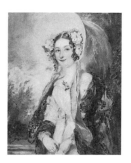

### 67 ROBERT THORBURN
## *Unknown Lady c.*1837

Watercolour on ivory, set in carved gilt-wood frame; 11.4 × 8.8cm
(4½ × 3½in)
COLLECTIONS: Purchased in 1971

Robert Thorburn (1818–1885) was born in Dumfries, the son of a
tradesman. After studying art at Edinburgh, in 1836 he travelled to
London to study at the Royal Academy schools. He exhibited his work at
the Academy from 1837 to 1884. Elected an associate of the Royal
Academy in 1848, he was awarded a gold medal at the Paris International
Exhibition of 1855. During the 1840s Thorburn shared the patronage of
fashionable society with Sir William Charles Ross. At about this time

Thorburn was patronised by Queen Victoria and Prince Albert. In later life he turned to painting in oils, a medium in which he was only moderately successful.

### 68 SIR WILLIAM CHARLES ROSS
*Baroness Howard de Walden and her Three Children* 1839

See pages 54 and 55

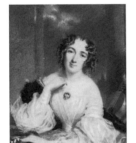

### 69 SIR FREDERIC WILLIAM BURTON
*Unknown Lady* 1836

Watercolour on ivory, set in ormolu frame; 12.7 × 10.3cm (5 × 4in); signed and dated on verso: *Frederic Wm. Burton, R.H.A., / 1836*
COLLECTIONS: O. Löwit, Vienna; Christie's, London, 8 June 1971, lot 7
EXHIBITED: Vienna (Albertina) 1924, no.125
REFERENCES: Schidlof 1964, I, p.119, & II, pl.101 no.186; Foskett 1972, I, p.190 & II, pl.33 no.105; Foskett 1987, p.503

The Irish artist Sir Frederic William Burton (1816–1900) was born in Co. Clare, the third son of Samuel Fredrick Burton, an amateur painter. He trained in Dublin, exhibited at the Royal Hibernian Academy in 1837, was elected an associate the same year, and made a member in 1839. He showed his work there regularly until 1854, and also later when he was based in London. He exhibited at the Royal Academy and elsewhere in London from 1842 to 1882. Burton was appointed director of the National Gallery in London in 1874, when he stopped practising as a professional artist, and was knighted in 1884. Burton died in London but is buried in Dublin. This miniature is one of his earliest examples, which are generally scarce.

### 70 SIR WILLIAM JOHN NEWTON
*Lavinia Anne Tarbutt, Mrs. Simcox Lee (d.1869)* 1840

Watercolour on ivory, set in wooden frame; 13.9 × 11.4cm (5½ × 4½in); signed and dated on recto: *W.J. Newton 1840*; inscribed on verso: *Mrs. Simcox Lee. / Sir Wm. J. Newton, / Pinxit. / Miniature Painter in ordinary / to Her Majesty & the Queen Dowger / 6 Argyll Street, / 1840.*

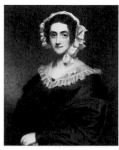

COLLECTIONS: Purchased in 1978
REFERENCES: Foskett 1984, p.45, ill.

Sir William John Newton (1785–1869) was born in London, the son of the engraver, James Newton. Trained as an engraver, he took up miniature painting and entered the Royal Academy schools in 1807, exhibiting his work in London from 1808 to 1861. Newton was appointed miniature painter to William IV and Queen Adelaide in 1833, and then painter to Queen Victoria, who knighted him in 1837.

### 71 SIR WILLIAM CHARLES ROSS
### *Maria, Lady Culme-Seymour* 1844

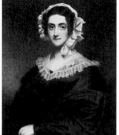

Watercolour on ivory, set in gilt-metal frame; 15.3 × 10.2cm (6 × 4in)
COLLECTIONS: Seymour family; Sotheby's, London, 27 March 1972, lot 55
EXHIBITED: Edinburgh (Scottish Print Club) 1937

Maria Louisa Smith was the sister of Sir Joseph Smith, 2nd Bt, of Tring Park in Hertfordshire. In 1844 she married the Revd Sir Robert Culme-Seymour, 2nd Bt, as his second wife, and this miniature by Ross is likely to have been a marriage portrait. Her husband was the eldest son of Lady Seymour [74], and he was a canon of Gloucester cathedral and chaplain to Queen Victoria. His first wife was Elizabeth Culme, whose name he added to his own.

### 72 CORNELIUS BEVIS DURHAM
### *Unknown Lady c.*1845

Watercolour on ivory, set in gilt-metal frame; 16.5 × 11.4cm (6½ × 4½in); signed on recto: *C. Durham*
COLLECTIONS: Purchased in 1987

Little is known of the origins of Cornelius Bevis Durham (fl.1825–1865), who lived and worked in London. He exhibited his work at the Royal Academy and elsewhere in London from 1828 to 1858. Durham won awards at the Society of Arts in 1825 and 1826, and in 1832 he was awarded a gold Isis medal. He also worked as an intaglio cutter.

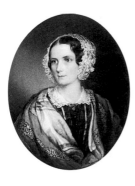

**73** ALFRED TIDEY

## *Lady Louisa Noel c.1845*

Watercolour on ivory, set in silver-gilt frame; 10.2cm (4in) high; inscribed on verso: *Louisa Noel by Alfred Tidey*
COLLECTIONS: Sotheby's, London, 31 July 1972, lot 21

Born in Worthing, Alfred Tidey (1808–1892) was the brother of watercolour painter Henry Tidey. He worked in London and exhibited at the Royal Academy and elsewhere from 1831 to 1877. He entered the Royal Academy schools in 1834. Tidey enjoyed a successful portrait practice, travelling extensively on the Continent, and in particular to Germany. A miniature of Lady Louisa Noel by Sir William Charles Ross was exhibited at the Royal Academy in London during 1846 and it is possible that this was another portrait of the same sitter. Noel is the family name of the Earls of Gainsborough.

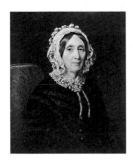

**74** SIR WILLIAM CHARLES ROSS

## *Jane Hawker, Lady Seymour (d.1852) 1846*

Watercolour on ivory, set in ormolu frame; 12.7 × 10.2cm (5 × 4in); signed and dated on verso: *Painted by Sir Wm. Ross R.A. 1846.*
COLLECTIONS: Seymour family; Sotheby's, London, 27 March 1972, lot 54

In 1789 Jane Hawker married Admiral Sir Michael Seymour KCB, who had a distinguished naval career and was created baronet in 1809. Ross also portrayed Lady Seymour's daughter-in-law, Lady Maria Culme-Seymour [71].

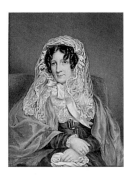

**75** SARAH BIFFIN, MRS E.M. WRIGHT

## *Unknown Lady* 1847

Watercolour on ivory, set in an ormolu frame; 15.2 × 11.4cm (6 × 4in);
signed and dated on verso: *Liverpool, 1847, / Painted by Miss Biffin, /
artist without hands.*
COLLECTIONS: Christie's, London, 6 July 1975, lot 47

Sarah Biffin (1784–1850), sometimes spelt Beffen, the daughter of a farm
labourer, was born at East Quantoxhead in Somerset without hands,
arms or feet. She taught herself to paint by holding a brush in her mouth.
Early in her life she was contracted to a Mr Dukes, who persuaded her
parents to allow her to tour the country, where she was exhibited as a
freak and a genius. Miss Biffin was paid a salary of five pounds a year and
the public paid a shilling or sixpence to watch her as she painted
miniatures for three guineas each, though she received no extra salary
for her efforts. Rescued from this servitude by the Earl of Morton, she
received royal patronage, and exhibited her work at the Royal Academy
from 1823 to 1850. Sarah Biffin died in Liverpool and is buried there in St
James's cemetery, where her grave is marked by an epitaph recording her
courageous life.

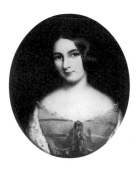

**76** CORNELIUS BEVIS DURHAM

## *Unknown Lady* 1849

Watercolour on ivory, set in a rectangular gilt-metal frame; 8.8cm (3½in)
high; signed and dated on verso: *Painted by Cornelius Bevis Durham, /
191 Regent Street / 1849*
COLLECTIONS: Purchased in 1973

This is one of two miniatures by Cornelius Bevis Durham in the
Merchiston collection [see also 72].

# REFERENCES

BAYNE-POWELL 1985
Robert Bayne-Powell, *Catalogue of Portrait Miniatures in the Fitzwilliam Museum, Cambridge*, Cambridge, 1985

COLDING 1953
Torben Holck Colding, *Aspects of Miniature Painting: Its Origins and Development*, Copenhagen, 1953

COOMBS 1998
Katherine Coombs, *The Portrait Miniature in England*, London, 1998

EDWARDS 1997
Sebastian Edwards (ed.), *Miniatures at Kenwood: The Draper Gift*, London, 1997

FOSKETT 1963
Daphne Foskett, *British Portrait Miniatures: A History*, London, 1963

FOSKETT 1964
Daphne Foskett, *John Smart: The Man and his Miniatures*, London, 1974

FOSKETT 1972
Daphne Foskett, *A Dictionary of British Miniature Painters*, 2 vols., London, 1972

FOSKETT 1974
Daphne Foskett, *Samuel Cooper 1609–1672*, London, 1974

FOSKETT 1979
Daphne Foskett, *Collecting Miniatures*, London, 1979

FOSKETT 1984
Daphne Foskett, 'Rediscovering 19th Century Portrait Miniatures', *The Antique Dealer & Collectors Guide*, May 1984, pp.42–5

FOSKETT 1987
Daphne Foskett, *Miniatures: Dictionary and Guide*, Woodbridge 1987 [incorporates *A Dictionary of British Miniature Painters*, 1st edn., London, 1972; and *Collecting Miniatures*, 1st edn., London, 1979]

LONG 1929
Basil S. Long, *British Miniaturists: 1520–1860*, London, 1929 [reprinted 1966]

MCKERROW 1982
Mary McKerrow, *The Faeds: A Biography*, Edinburgh, 1982

**MURDOCH 1978**
John Murdoch, 'Hoskins' and Crosses: Work in Progress', *Burlington Magazine*, CXX, May 1978, pp.284–90

**MURDOCH 1997**
John Murdoch, *Seventeenth-Century English Miniatures in the Collection of the Victoria & Albert Museum*, London, 1997

**MURDOCH ET AL. 1981**
John Murdoch, Jim Murrell, Patrick J. Noon and Roy Strong, *The English Miniature*, New Haven and London, 1981

**REYNOLDS 1980**
Graham Reynolds, *Wallace Collection: Catalogue of Miniatures*, London, 1980

**REYNOLDS 1988**
Graham Reynolds, *English Portrait Miniatures*, Cambridge, 1988 [1st edn., 1952]

**REYNOLDS 1999**
Graham Reynolds, *The Sixteenth and Seventeenth-Century Miniatures in the Collection of Her Majesty The Queen*, London, 1999

**SCHAFFERS-BODENHAUSEN & TIETHOFF-SPLIETHOFF 1993**
Karen Schaffers-Bodenhausen & Marieke Tiethoff-Spliethoff, *The Portrait Miniatures in the Collection of the House of Orange-Nassau*, Zwolle, 1993

**SCHIDLOF 1964**
Léo R. Schidlof, *The Miniature in Europe in the 16th, 17th, 18th and 19th Centuries*, 4 vols., Graz, 1964

**WALKER 1992**
Richard Walker, *The Eighteenth and Early Nineteenth-Century Miniatures in the Collection of Her Majesty The Queen*, Cambridge, 1992

**WALKER 1997**
Richard Walker, *Miniatures: A Selection of Miniatures in the Ashmolean Museum*, Oxford, 1997

**WALKER 1998**
Richard Walker, *Miniatures: 300 Years of the English Miniature illustrated from the Collections of the National Portrait Gallery,* London, 1998

**WILLIAMSON 1897**
George C. Williamson, *Richard Cosway R.A. and his Wife and Pupils: Miniaturists of the Eighteenth Century*, London, 1897 [2nd edn., 1905]

**WILLIAMSON 1902**
George C. Williamson, *George Engleheart* London, 1902

**WILLIAMSON 1903**
George C. Williamson, *Andrew & Nathaniel Plimer: Miniature Painters, their Lives and their Works*, London, 1903

**WILLIAMSON 1906-8**
George C. Williamson, *Catalogue of the Collection of Miniatures the Property of J. Pierpont Morgan*, 4 vols., London, 1906–8

## EXHIBITION CATALOGUES

### BATH 2002
Susan Sloman *et al.*, *Pickpocketing the Rich: Portrait Painting in Bath 1720–1800*, The Holburne Museum of Art, Bath, 2002

### BATH, EDINBURGH & LONDON 1999
Anne Sumner and Richard Walker (eds.), *Secret Passion to Noble Fashion: The World of the Portrait Miniature*, The Holburne Museum of Art, Bath; Phillips Auctioneers, Edinburgh; D.S. Lavender (Antiques) Ltd, London, 1999

### DUBLIN 2000
Paul Caffrey, *Treasures to Hold: Irish and English Miniatures 1650–1850 from the National Gallery of Ireland Collection*, National Gallery of Ireland, Dublin, 2000

### EDINBURGH 1937
*The Scottish Fine Arts and Print Club: Tenth Loan Exhibition*, Royal Scottish Academy Galleries, Edinburgh, 1937

### EDINBURGH 1965
Daphne Foskett, *British Portrait Miniatures*, Scottish Arts Council Gallery, Edinburgh, 1965

### EDINBURGH 1996–7
Stephen Lloyd, *Portrait Miniatures from the Collection of the Duke of Buccleuch*, Scottish National Portrait Gallery, Edinburgh, 1996–7

### EDINBURGH 1999
Stephen Lloyd, *Raeburn's Rival: Archibald Skirving 1749–1819*, Scottish National Portrait Gallery, Edinburgh, 1999

### EDINBURGH 2001
Stephen Lloyd, *Portrait Miniatures from the Clarke Collection*, Scottish National Portrait Gallery, Edinburgh, 2001

### EDINBURGH 2002
Stephen Lloyd, *Portrait Miniatures from the Dumas Egerton Collection*, Scottish National Portrait Gallery, Edinburgh, 2002

### EDINBURGH 2003
Stephen Lloyd, *Portrait Miniatures from the Daphne Foskett Collection*, Scottish National Portrait Gallery, Edinburgh, 2003

### EDINBURGH 2004
Stephen Lloyd, *Portrait Miniatures from the National Galleries of Scotland*, Scottish National Portrait Gallery, Edinburgh, 2004

### EDINBURGH & LONDON 1995–6
Stephen Lloyd *et al.*, *Richard & Maria Cosway: Regency Artists of Taste and Fashion*, Scottish National Portrait Gallery, Edinburgh, and National Portrait Gallery, London, 1995–6

### LONDON 1974
Daphne Foskett, *Samuel Cooper and his Contemporaries*, National Portrait Gallery, London, 1974

### LONDON 1983
V.J. Murrell and Roy Strong, *Artists of the Tudor Court: The Portrait Miniature Rediscovered*, Victoria & Albert Museum, London, 1983

### LONDON 1988
*Childhood*, Sotheby's, London, 1988

### LONDON 1993
Richard Walker (ed.), *The Monarchy in Portrait Miniatures from Elizabeth I to Queen Victoria*, D.S. Lavender (Antiques) Ltd, London, 1993

LONDON & NEW HAVEN 2001−2
Catharine MacLeod and Julia Marciari Alexander
*et al., Painted Ladies: Women at the Court of
Charles II*, National Portrait Gallery, London, and
Yale Center for British Art, New Haven, 2001−2

NEW HAVEN 1979
Patrick J. Noon, *English Portrait Drawings &
Miniatures*, Yale Center for British Art, New
Haven, 1979

NEW HAVEN, CHARLESTON &
ANDOVER 2000−1
Robin Jaffee Frank, *Love & Loss: American
Portrait and Mourning Miniatures*, Yale
University Art Gallery, New Haven; Gibbes
Museum of Art, Charleston; and Addison Gallery
of American Art, Phillips Academy, Andover,
2000−1

NEW YORK 1996−7
Graham Reynolds and Katharine Baetjer,
*European Miniatures in The Metropolitan
Museum of Art*, The Metropolitan Museum of Art,
New York, 1996−7

NEW YORK, SAN MARINO, RICHMOND
& LONDON 1996−7
Christopher Lloyd and Vanessa Remington,
*Masterpieces in Little: Portrait Miniatures from
the Collection of Her Majesty The Queen*, The
Metropolitan Museum of Art, New York; The
Huntington Library, Art Collections and
Botanical Gardens, San Marino; Virginia Museum
of Fine Arts, Richmond; and The Queen's Gallery,
Buckingham Palace, London, 1996−7

WASHINGTON 1983
Monroe H. Fabian, *Mr. Sully, Portrait Painter:
The Works of Thomas Sully (1783–1872)*, National
Portrait Gallery, Washington DC, 1983

# INDEX OF ARTISTS & SITTERS

References are to catalogue numbers
names of sitters are shown in *italics*